A HISTORY OF
SOUTH CAROLINA
LIGHTHOUSES

JOHN HAIRR

Charleston — London

THE
History
PRESS

Published by The History Press
Charleston, SC 29403
www.historypress.net

First published 2014

Manufactured in the United States

ISBN 978.1.62619.077.1

Library of Congress CIP data applied for.

*Purchased by Audrey H. while in
S.C. for a family reunion.
Oct. 2014*

CONTENTS

PREFACE

A nother lighthouse book? That is a question that quickly comes to mind as I stand on the catwalk of the Hunting Island Lighthouse and contemplate putting together another book about lighthouses of the southeastern United States. There are lots of reasons not to undertake such a project, not the least of which is the fact that there are already enough lighthouse books on the market to fill a decent-sized library. There are several other projects waiting for my attention, but the idea of putting together a book about the lighthouses that once cast their beams across the sandy beaches of the Palmetto State just won't go away.

The idea for this book began more than two decades ago as I gathered bits of the story while researching the maritime history of the Carolina coast. As I looked into the early lighthouse history of the Palmetto State, it quickly became apparent that much of what we think we know about the history of South Carolina's lighthouses is not accurate. Many of these inaccuracies were first presented in official publications of government agencies, as well as other well-known publishers, back in the early and mid-twentieth century. They persist into the present century.

The most problematic of these myths are the accounts of the lighthouses that stood on Morris Island, especially the one built by the British government on the eve of the Revolutionary War. Every book, tourist brochure, journal article or newspaper clipping claims that the original lighthouse at Charleston was built in 1767, and most base

this statement on the wording of a copper plaque that was attached to the structure when it was originally built that has subsequently been lost. There is no problem with this bit of local lore, as other sources corroborate the tale. The problem begins when trying to sort out what happened to the original Charleston Lighthouse. Many sources state that it stood until it was blown up by the Confederates defending Charleston in the early days of the War Between the States, while others argue that it was torn down and replaced in the early nineteenth century. But I knew that neither of these solutions was correct because, in the course of researching the Revolutionary War activities of Loyalist colonel David Fanning, I ran across an account of a British soldier who was on board a ship that was attacking Charleston in the winter of 1780 who reported that the lighthouse was blown up by the defenders of the city. This action took place over three years before the country had won its independence from Great Britain and nine years before the United States took over the administration of the lighthouses in the new Republic.

In an effort to shed light on the history of this lighthouse, I delved into the records in the National Archives. There, in Records Group 26, where all of the records of the U.S. Coast Guard and its parent organizations are housed, I combed through the old documents, trying to sort out the mess. In the records relating to the Charleston Lighthouse, there is a typescript document prepared in April 1950 as an official document for the Historical Section of the Public Information Division of the U.S. Coast Guard. The document, titled "History of Charleston Main Light, Morris Island, South Carolina," begins with the following unequivocal statement: "The Charleston Main Light, located on Morris Island, at the entrance to Charleston, South Carolina, was one of the colonial lights turned over to the Federal Government under the terms of the Act of August 7, 1789."

I, too, am guilty of perpetuating this story. In a publication I authored back in 2002, *South Carolina Lighthouses*, I tried to tell the facts as I had uncovered them up to that point. But the heavy hand of my editor changed the account, a fact I did not learn until after the publication was printed. My collaborator and publisher on that project was photographer and lighthouse aficionado, who subsequently told me that although I was correct from a historical point of view, it would be best if we didn't rock the boat, as the locals would not be too pleased and sales would suffer. The edited version of the story from the 2002 publication states,

"The first lighthouse was constructed on Morris Island at the mouth of Charleston Harbor in 1767 during the reign of King George III. It was one of twelve lighthouses built by British colonial governments and ceded to the fledging nation after Congress took charge of lighthouses by creating the U.S. Lighthouse Establishment in 1789."

Eleven years later, I am glad that Chad Rhoad and the folks at The History Press have given me the opportunity to tell the story of not only the Charleston Lighthouse but also all the official lighthouses that have stood watch over the shores of South Carolina. As I did with the structures at Charleston, I have gone back into the archives to try to piece together the stories of these historic structures. This includes not only the National Archives but also the South Carolina Archives, where the friendly and helpful staff helped me track down some really obscure documents concerning South Carolina's aids to navigation. I have supplemented this archival material with newspaper accounts and other contemporary records where available. This, in turn, was supplemented by fieldwork on the ground, with visits to the respective lighthouses. The communities where these lighthouses were built are as unique as the structures themselves. I am happy to report that the folks I met along the way were always friendly and encouraging; they validated South Carolina's reputation as a place where hospitality is still the norm.

This book is by no means infallible, as history, like other sciences, is constantly changing as we learn more and uncover new information. Hopefully this book will provide a good base for future researchers into the maritime history of the region. There are endnotes and a list of sources at the end of the book to help serious historians look deeper into the history of the respective lighthouses.

Large parts of the story have long since vanished, gone when the people who manned the lighthouses passed on. It is unfortunate that many of these people didn't take the time to preserve some of their more colorful experiences. We are fortunate, however, that many of the state's lighthouses have survived, standing as mute witnesses to the power of the sea and man's attempts to safely travel about on the waters of the world. Many of these structures would not be here if it were not for the work of various state, federal and local governmental agencies working with volunteers and nonprofit foundations.

From my vantage point atop the Hunting Island Lighthouse, I can see evidence of coastal erosion that long ago claimed the first Hunting

Island Lighthouse and very nearly claimed the present cast-iron structure. Fortunately, they were able to move this lighthouse to safety, and the ocean has stopped its relentless gnawing away of the sandy beach—at least for the time being. Farther up the coast, at Morris Island, one can see what happens when the ocean is not held back. With our ever-changing climate, who knows whether these and other lighthouse structures along the South Carolina coast will be high and dry or submerged under the sea ere one hundred years passes.

INTRODUCTION

South Carolina has a rich maritime history that has played out over the past five centuries along a coast that stretches nearly 200 miles along the Atlantic Ocean from Little River Inlet to the Savannah River. Including the islands, bays and inlets, the state boasts 2,876 miles of shoreline. The state is famed for its wide, sandy beaches; remote river deltas; bustling ports; and barrier islands.

Despite an absence of rocky headlands or bold promontories, there is an abundance of natural hazards reaching out from South Carolina into the Atlantic. Ever-shifting shoals and sandbars have challenged mariners passing down this long and sometimes dangerous stretch of coast. In addition to these hazards, there are frequently storms, fog, haze and other meteorological conditions that obscure visibility and threaten people's safety.

Important features of the South Carolina coast are its bays and harbors. Ships from all over the world visit the Palmetto State's ports on a regular basis. In addition to the large vessels engaged in international commerce, the state has historically relied on a thriving coastal trade with local ports. The state is home to Charleston Harbor, a world-class port facility that has been South Carolina's—and perhaps the South's—most famous port for nearly four centuries. Yet even Charleston Harbor is plagued with constantly shifting sandbars and shoals that have claimed many shipwrecks in the port's long and illustrious history.

Thanks to the combination of a brisk seaborne commerce and a lively coastal trade, there developed a need for a reliable system of markers and other aids to navigation along the South Carolina coast. Sometimes, local landmarks were used, such as a windmill or a house. But as time went by and traffic increased, more elaborate and reliable means of marking the coast were developed.

In an effort to centralize the administration of the various lighthouses scattered along the coast of the former British colonies, the federal government took responsibility for the young nation's aids to navigation in 1789, thanks to legislation passed by the First Congress of the United States. There were a dozen lighthouses scattered along the coast from Maine to Georgia, including the Charleston Lighthouse. As will be discussed later, the lighthouse at Charleston was not the colonial-era lighthouse that was built by British authorities back in 1767. That particular structure was blown up in February 1780. The second tower was constructed by the State of South Carolina prior to the structure being ceded to the United States in 1790 and thus has the distinction of being the only lighthouse completed by the state government before the federal government took over control of the country's aids to navigation.

South Carolina's first lighthouse dates back to 1767, but aids to navigation date back even earlier, to a point in time when mariners found fires in baskets mounted atop poles, large clumps of trees, windmills, church spires or even candles in a window useful tools for finding their way safely into port on a foggy or stormy evening.

Nearly two hundred years after the construction of the first official lighthouse at Charles Town, one of the most modern lighthouses in the world was built on the opposite side of Charleston Harbor on Sullivan's Island. This triangular steel-and-aluminum tower became the last in a long line of lighthouses built to guide mariners safely along the shores of the Palmetto State.

CHARLESTON'S EARLIEST LIGHTHOUSES

The first lighthouse constructed at the mouth of Charleston Harbor was built between 1766 and 1769, in the days when South Carolina was still a British colony and Charleston was still known as Charles Town. This historic lighthouse was destroyed during the Revolutionary War by the Whig defenders of Charles Town in February 1780.

Virtually all accounts of the early years of this tower base their chronology of the history of this lighthouse on information that was contained on a copper tablet that commemorated completion of the lighthouse. This tablet contained the following inscription: "The First Stone of the Beacon was laid on the 30th of May 1767 in the seventh year of his Majesty's Reign, George the III."[1]

Unfortunately, the tablet no longer exists and has not been seen for more than a century, so it is impossible to determine the authenticity of the artifact. But there are some newspaper accounts that corroborate the claims that the lighthouse was indeed begun in May 1767. For instance, this note from the *Virginia Gazette* states, "June 5. On Saturday the commissioners of pilotage laid the first stone in the new beacon, or light-house, on Middle Bay Island, near the bar."[2]

The previous year, officials at Charles Town had entered into a contract with a talented architect named Samuel Cardy for the construction of a lighthouse on Middle Bay Island, which was one of the islands that eventually became what we know today as Morris Island. Cardy went

to work almost immediately after receiving the contract in the fall of 1766. Press accounts of the day noted this bustle of early activity: "The commissioners of pilotage for the bar and harbor of Charles Town have contracted with Mr. Samuel Cairdy [sic] for building immediately a beacon or light house of brick, on Middle-Bay Island, near the bar, to be 115 feet high, with a lanthorn [sic] on the top which will be of the greatest utility to navigation."[3]

Word of the new lighthouse spread as far afield as New York, where newspapers informed mariners traveling to the Carolinas of the new structure: "A beacon is forthwith to be erected upon Middle-Bay Island, near the bar, to be built of brick 115 feet high, with lanthorns [sic] on the top, so that it may occasionally serve as a light-house, which will be of great service to the navigation."[4]

Less than a year after signing the contract, work at the site had progressed to the point where the structure was visible to travelers entering and leaving Charles Town Harbour. "We have the pleasure of acquainting the publick [sic] that Samuel Cardy, the contractor for building the beacon near the bar, has raised the same upwards of 20 feet high, which he was not obliged to do before the end of November. It is expected that the whole will be completed in eight months."[5]

By the following summer, Cardy's lighthouse was completed. "We have the pleasure of informing the publick [sic], that yesterday the brick work of the Beacon or Light-House on Middle-Bay Island was finished, and that Mr. Samuel Cardy, the contractor, has likewise raised the principal part of the Lanthorn [sic]."[6]

In September 1768, the lighthouse at Charles Town came to the attention of none other than Benjamin Franklin, who received a letter from his friend, Peter Timothy. The latter extolled the virtues of the thriving colony, including the new lighthouse: "A Beacon and Light-House for this Harbour are near finished on Middle Bay Island."[7]

During the winter of 1770–71, William Gerard de Brahm, who held the grand title of "His Majesty's Surveyor-General for the Southern district of North America," surveyed the coast between Charles Town and Cape Florida. He mentioned that he utilized the Charles Town Lighthouse as the base for determining longitude of that section of coast. He later traveled from England back to Charles Town to double check his calculations for the lighthouse, which he figured to be at 80° 42' 43" west of London. The marine chronometer had not yet been

invented, so de Brahm had to figure out his longitude based on studies of the heavenly bodies.

De Brahm later published a description of the entrance to Charles Town, which read in part, "The Port of Charles Town is shut up by a Bar stretching from North to South 6 miles, which has 6 Channels, the best of the six is that which nears E. by S. 2 ½ miles from the Light House lately erected in Latitude 32° 40' 00" on James Island here the Variation continued E 1 52' anno 1770."[8]

When the Revolutionary War broke out in 1775, Charles Town became a center of activity, coveted by the leaders of both factions. Throughout the war, from 1775 until the granting of the young country's independence in 1783, the city played a key role in the strategies of both parties.

The Charles Town Lighthouse survived the first attack against Charles Town by British forces in 1776, with most of the action taking place on the northeast shore of the harbor at Fort Moultrie. The lighthouse made an excellent observation post for the defenders of the city. In the winter of 1776, Thomas Pinckney mentioned plans for obtaining a "Spy Glass for the Lighthouse." This would no doubt have been a great benefit to the South Carolinians as they tried to keep track of the British fleet offshore.[9]

The British fleet was repulsed in its initial foray against Charles Town, and the city remained under control of Whig forces for the next four years. But in 1780, another British expedition arrived off Charles Town Harbour, this one much better organized than the one in 1776.

The Charles Town Lighthouse was destroyed during the second British attack on the city. The destruction of the lighthouse was not the work of the British attackers. Instead, South Carolina's first lighthouse was destroyed by the local defenders of Charles Town.

We know few details about the destruction of the lighthouse. Our best account was preserved by Captain Peter Russell, who was a member of the Sixty-fourth Regiment and participated in the British attack. Russell kept a journal of the events he witnessed, a copy of which survived the war. While riding aboard one of the British ships in the waters between Edisto and Charles Town, Russell spoke with crewmen from the HMS *Blonde* who noted that they had seen the defenders blow up the structure. His journal gave a terse entry about this significant event: "The *Blonde* saw the Light House at Charles Town blown up by the Rebels."[10]

Unfortunately, no records have come to light telling exactly who among the defenders of Charles Town blew up the lighthouse or who issued the order to do so. What we do know is that this action destroyed the lighthouse built during the colonial period. The entrance to Charles Town Harbour remained dark for the rest of the war and would not be rebuilt until peace was restored and South Carolina an independent state.

The first mention of rebuilding the important lighthouse came shortly after South Carolina and the rest of the colonies gained their independence from Great Britain in 1783. In response to a message from Governor William Moultrie on February 9, 1785, a special committee was appointed by the general assembly to investigate the possibility of reestablishing a lighthouse and other aids to navigation for Charleston Harbor. The committee's report, dated July 1, 1785, pointed out that it was in favor of building a new lighthouse and even proposed a means of paying for the project. The brief report stated, "That in their opinion the Rebuilding of a Light-House and Erecting Beacons, as leading marks over the Bar, for the Port of Charleston, would be of Real utility to vessels coming to this port, therefore Recommend that a Committee be appointed to bring a bill for laying a Tax of three pence per ton on all vessels Entering in and Clearing out at the Customs House in this City for the express purpose of Rebuilding the Light House & Beacons for the Bar of Charleston Harbor."[11]

The legislature authorized the special tax in March 1785 and shortly thereafter began raising money to relight the entrance to Charleston Harbor. Money was slow to come in, so it took time to raise the funds necessary to build a lighthouse. By February 1787, the city treasurer of Charleston reported that £935.18.9 had been collected, of which £225.17.8 had been spent erecting buoys and beacons. There was still not enough money on hand to build a lighthouse.[12] This is important in that it demonstrates that this lighthouse was built with state and local funds during a period between the end of British administration and the takeover of aids to navigation by the federal government of the United States. The lighthouse they funded and built, which was subsequently turned over to the federal government, was, in fact, the second Charleston Lighthouse, not the first.

Not everyone was pleased with the tax. Some mariners became impatient and questioned whether the funds collected were being put

to some other use. One of the most vocal complainers was Boonen Graves, consul general of the United Netherlands, who in February 1787 complained in a letter to Governor Moultrie about paying a tax for which there was nothing to show. A special legislative committee investigated the matter and found that the funds were being properly used. The committee noted, "They further Report that the whole sum which has been paid by the Subjects of the United Netherland towards erecting the Light House and Buoys amounts to six pounds fourteen shillings and nine pence, and that as no Discrimination is made respecting the Tonnage between our own Citizens and Foreigners it would be unreasonable to return the said sum."[13]

Exactly when the second Charleston Lighthouse was completed is uncertain. Based on the investigation into Graves's complaint, we know that work on the structure had not begun by the winter of 1787. The South Carolina General Assembly passed a resolution on January 29, 1791, directing that the balance due to the commissioners for erecting the lighthouse at Charleston be paid out of the public treasury. So officials must have been satisfied with the work done on the new lighthouse by that date.[14]

The date can be narrowed down even further, thanks to a notice about a fire knocking the lighthouse out of service in July 1790—so it must have been operational at some point prior to that date. We know that in January 1790, the general assembly passed "An Act for Ceding and Vesting in the United States the Lighthouse on Middle Bay Island within the Bar of Charleston." This act was ratified in response to the passage of "An Act for the Establishment and Support of Light-Houses, Beacons and Buoys," passed by the U.S. Congress in 1789 and signed into law by President George Washington on August 7, 1789. This act gave control of the various lighthouses and aids to navigation across the states to the federal government. Interestingly, Thomas Tucker and William Smith, South Carolina's representatives to the Congress, were not in favor of the bill, as they believed some of the language infringed upon state's rights and that much of the work could be handled by local port authorities. Tucker offered an amendment for local funding that was struck down. Smith, however, was successful in having language relating to harbor pilots removed.[15]

Few details about construction of the second Charleston Lighthouse survive. Although the tower was made of stone, much of the interior of

the structure, including the stairway and the frame for the lantern, was built of wood. We know this because of the fact that the woodwork of the lighthouse was prone to catching fire. The first such fire occurred on the evening of July 1, 1790. A notice to mariners of the fact that the light was temporarily out of commission provides some details about the incident: "The commissioners of Pilotage for the bar of Charleston give notice that lanthorn [*sic*] of the light-house was, on the night of the first instant, consumed by fire, so that there can be no light shown till the light house is repaired."[16]

The Charleston Lighthouse caught fire again, this time with even more destructive results. On the evening of July 21, 1799, a fire raged through the tower, consuming every piece of flammable material on the site, including the lamphouse and wooden stairs. Daniel Stevens, who was the lighthouse superintendent at Charleston, issued a warning to mariners stating that the light was temporarily out of commission, that the walls of the structure could still be used as a daymark and that the light would remain out of service in the evening until a temporary light could be mounted to the top of the old lighthouse.[17]

Stevens wasted little time soliciting proposals for repairing the Charleston Lighthouse. A notice dated September 4, 1799, stated that the nature of the repairs and upgrades to the lighthouse were quite extensive. Stevens's notice listed the following particulars:

1st. The building the Lanthern Story, of Iron, of an octagonal form, particular parts thereof to be covered with sheet Copper, no part of which is to be of wood; the floor of the lanthern to be of best flagstones, and the trap door of iron.

2d. The Stairs from the bottom to the floor of the lanthern, to be of Brick or Stone, or of Wood, as shall hereafter be agreed upon.

3d. The Oil Cistern to be completely repaired, and securely leaded as it was before it was burnt, with an iron trap door, and lock.

4th. To build a Brick Oil Vault, at a distance from the Light-House, and a Wooden Cistern therein, with a shed over the whole.

5th. To replace four substantial Window Frames and Sashes Glazed with the best white clear Glass, in each of the first, second, third and fourth stories; also a strong well-made Door Frame and Door of good materials of yellow pine, to the entrance of the Light-House, and a strong well-made Stock Lock.[18]

The extensive repairs needed for the Charleston Lighthouse and the ancillary structures proved to be expensive. According to records in the National Archives, the work cost nearly $6,000, with Congress appropriating $5,950 to fix the damage on May 7, 1800.[19]

Superintendent Stevens announced on November 10, 1800, that the Charleston Lighthouse was back in operation. He pointed out that the light had been "completely rebuilt, having a secure Stairs within, built of stone and brick, and an iron Lantern on top, covered with copper, perfectly in every respect secure from an accident of fire, wherein is now exhibited a full and brilliant Light."[20]

One of the earliest descriptions of the second Charleston Lighthouse was provided by Captain Lawrence Furlong in his *American Coast Pilot* for 1800. He wrote, "Charleston Light-House is built of brick and situated on an Island which you leave to larboard hand going in, on low sandy land, about 80 feet high, the lower part of which is white and the upper part black."[21]

The Charleston Lighthouse underwent extensive modifications, most notable of which was the raising of the height of the tower in 1812. But war with Great Britain broke out in that year, providing ominous implications for the lighthouse. The war years were eventful ones for the lighthouse and the people who lived nearby. Keepers could stand on the beach and watch privateers leaving Charleston Harbor. They could even hear the gunfire of offshore naval engagements between British ships attempting to blockade the port and American ships coming in and out of the port. There were also several shipwrecks near the lighthouse.

The most significant episode for the Charleston Lighthouse during the War of 1812 was the arrival of the HMS *Aeolus* off the entrance of Charleston Harbor in the winter of 1813. The British ship intercepted several vessels en route to Charleston, including a schooner called the *Federal Juck*. This schooner belonged to the U.S. Lighthouse Service, and on board the vessel was Captain Winslow Lewis and the lighting apparatus not just for Charleston but for the other lighthouses along the coast of the southern states. Lewis had made extensive modifications to the lights in the New England and Mid Atlantic states, improving the lights with his system based on the light developed by Ami Argand, and was in the process of completing the upgrades to the nation's lighthouses by installing the new lamps and other machinery.

Realizing the importance of the equipment, the captain of the *Aeolus* placed the lamps and accompanying implements on board his ship. Once the prisoners and materials were securely on board the *Aeolus*, the *Federal Jack* was set on fire and destroyed. Later, the British warship stopped and boarded another vessel, the *Canton*, and placed several of the prisoners on board, including Lewis. The captain of the *Federal Jack*, Captain Brigham, was not released and remained on board the British ship. The *Canton* proceeded on its journey into Charleston, where Lewis shared the bad news of his ordeal.[22]

Local port officials moved to install a temporary lighting system in the newly renovated lighthouse. Whether the old lighting system was in good enough shape to be reinstalled after having been removed from the lighthouse is uncertain. The officials issued a notice on March 25, 1813, describing their predicament: "The light-house, having been raised ten feet and now finished, will be lighted on Sunday the 28th inst. The reflectors intended for the same having been taken by the British frigate *Aeolus*, the light will be only temporary, until the reflectors can be replaced."[23]

Permanent replacements for the lighting apparatus that was captured by the *Aeolus* were not installed until after the war was over. Work to replace the temporary lighting system was completed in the summer of 1816 and went into operation on November 1 of that year. Lewis described the new light as follows: "At the distance of eight or nine leagues, the time of darkness will be twice that of light. As you approach it, the time of light being visible will increase, and that of darkness decrease, until you get within three leagues, when the light will not wholly disappear, but the difference between the greatest and the least strength of the light will be as 1 to 44."[24]

Lewis's improved lighting apparatus remained in service atop the Charleston Lighthouse for many years. Over the next twenty years, various navigators commented upon the lighthouse, including Robert Mills, who provided the following description in his 1832 guidebook, *American Pharos, or Light-House Guide*: "The lighthouse is erected on Light House Island, at the entrance of Charleston Harbor, in latitude 32° 40' longitude 79° 40'. The elevation of the lantern is 125 ½ feet above the sea, and [it] contains a revolving light which may be seen 8 or 9 leagues, at which distance the time of darkness will be twice that of light; as you approach it the time of darkness decreases, and light increases, until

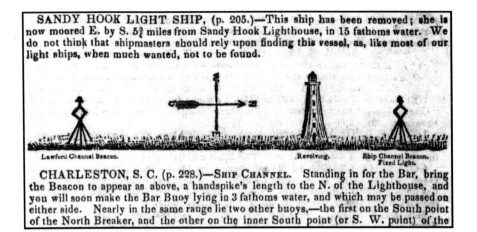

SANDY HOOK LIGHT SHIP, (p. 205.)—This ship has been removed; she is now moored E. by S. 5¾ miles from Sandy Hook Lighthouse, in 15 fathoms water. We do not think that shipmasters should rely upon finding this vessel, as, like most of our light ships, when much wanted, not to be found.

Lawford Channel Beacon. Revolving. Ship Channel Beacon. Fixed Light.

CHARLESTON, S. C. (p. 228.)—SHIP CHANNEL. Standing in for the Bar, bring the Beacon to appear as above, a handspike's length to the N. of the Lighthouse, and you will soon make the Bar Buoy lying in 3 fathoms water, and which may be passed on either side. Nearly in the same range lie two other buoys,—the first on the South point of the North Breaker, and the other on the inner South point (or S. W. point) of the

Diagram from the *American Coast Pilot* showing the Charleston Lighthouse and the range beacons leading into Charleston Harbor in 1846.

you get within 3 leagues, when the light will not totally disappear. The intensity of the light is as 24 to 1. To enter Charleston Bar, bring the light to bear W.N.W."[25]

In a July 1851 report to the U.S. Lighthouse Board concerning the lighthouses along the East Coast, Lieutenant David Porter of the U.S. Navy made several favorable comments about the lighthouses in South Carolina, He wrote of the Charleston Lighthouse, "The Charleston light is a very good one…and shows aloft at a distance of eighteen miles, which is sufficient for all purposes of navigation." He pointed out that fog was a common problem plaguing mariners venturing into or out of Charleston Harbor and that the beacons should be improved and a fog whistle installed on the Charleston Lighthouse.[26]

There have been some suggestions that the Charleston Lighthouse was rebuilt in 1838.[27] However, Porter's and Mill's comments concerning the light argue against this. In addition, there is no mention of the reconstruction or major modifications to the main lighthouse on Morris Island during the 1830s. There were, however, several appropriations for beacons on Morris Island, but these were for various range beacons and not for the main lighthouse.[28]

The Charleston Lighthouse underwent significant upgrades and improvement between 1838 and 1842. An individual who identified

himself merely as "L.R.G." visited the lighthouse in the fall of 1842 and provided a thorough description of the upgraded lens:

> *The reflectors now in the lantern of the light house are of a paraboloidal form, and the burner of an Argand lamp is so placed in each that the flame may be near the focus, and the rays consequently are reflected in the manner stated. Twelve of these reflectors are attached to a light iron frame, in sets of six each, on opposite sides, each set being arranged in a pyramidal form, three in a row, two in the second row, above the intervals between those lower, and the remaining one on top. The lower of this axis of the frame rests on the shorter axis, also vertical, and the latter is caused to revolve by a weight and train of wheels, whose motion of the shorter axis is transmitted to the upper by friction between the two ends, and the light is of course exhibited twice in any revolution of the axis.*[29]

In September 1854, a fierce hurricane ravaged the coast of the United States from Florida to Virginia. The winds and floodwaters from this storm, which made landfall along the coast of Georgia somewhere between Brunswick and Savannah on September 8, were keenly felt in Charleston, where much damage was sustained to homes and businesses. Most of the islands along the coast of South Carolina were inundated by the storm surge accompanying this hurricane.[30] Morris Island was one of several places to experience the destructiveness of this storm. Fortunately, the lighthouse came through with only minor damage, but the quarters for the light keeper and his assistant were totally wrecked.

The Lighthouse Board asked Congress for $4,000 to replace the damaged dwelling and outbuildings. "The estimate may seem to be large," they explained, "but a liberal allowance must be made for land transportation."[31] It also made a request for another $11,000 to be spent on the lighthouse itself. Changes in the top of the tower and the installation of a "first-order lens, fixed, illuminating 270°" would cost $9,500. "Contingencies" would require $1,000, while hurricane damage could be repaired for $500. Much to everyone's delight, Congress appropriated $17,500 for the Charleston Lighthouse on August 18, 1856.[32]

The repaired and refurbished Charleston Lighthouse and the new lighthouse at Cape Romain were lit simultaneously on January 1, 1858. The lighthouse on Morris Island was described on a nautical chart of

Charleston Harbor prepared in 1858 by the U.S. Coast Survey: "The Light House is on the North end of Morris Island and shows a fixed light. The Lantern is 133 feet above the level of the sea and in clear weather can be seen seventeen miles. There is a Lt. Boat 12 Miles from the s.w. end of Rattlesnake Shoal which serves as a guide for passing clear."[33]

The people of Charleston were very pleased with the improvements to their lighthouses and other aids to navigation. In fact, local officials were so pleased that they instructed their congressional delegation to resist attempts being made by New York legislators to return the U.S. Lighthouse Board to the way it had been run prior to the reforms enacted in 1852. A portion of a December 1858 report prepared by a legislative committee gives an important firsthand description of the aids to navigation in Charleston Harbor on the eve of the Civil War:

> *Charleston Harbor affords a good illustration of the two systems. Three years since, we had one light-house with Argand lamps and reflectors, with its range beacon, in which was a lantern but "dimly burning," while for the overall channel and on Sullivan's Island, there were a species of dark lanterns hung at the top of tall poles. At present, we have nine superb Fresnel lights, to which will soon be added a tenth at Mount Pleasant, in addition to the two on the lightship on Rattlesnake Shoal. Taking them in their geographical order, we have, first, the battery beacon, a graceful cast iron shaft resembling a colossal candelabra, supporting the lantern and its sixth-order lens, illuminated with a powerful gas light. Next, Castle Pinckney Beacon, a red light in a fifth-order lens; then, Fort Sumter beacons, on a brick tower within the Fort, with a fifth-order lens; on Sullivan's Island, two range beacons for the Main Ship Channel, with lens and reflector lights of dazzling brilliancy; on Morris Island, two range beacons of the same character, for the Overall Channel; and last, the magnificent second-order lens light upon Charleston Lighthouse, and its new range beacon, with a lens and reflector light, to guide vessels crossing the outer bar. Besides these, there is a fine Lightship on Rattlesnake Shoal, and soon there will be a sixth-order lens beacon put up at Mount Pleasant. For these various structures, including new dwellings for keepers at the overall beacons, Charleston Lighthouse and Mount Pleasant, and the entire renovation of Charleston Lighthouse, with the new lightship for*

Rattlesnake Shoal, there will have been expended about $50,000 by the present Board, besides a large sum for maintaining them and buoying the various channels. [34]

The improved Charleston Lighthouse was in service for only about three years. As with many other lighthouses along the southern coast, Confederate authorities ordered that the Charleston Lighthouse be destroyed early in the war in an effort to keep it from being beneficial to the Union navy.

South Carolina officials did not make the decision without studying the lighthouses lining the coast of the state. In January 1861, a committee investigated the operations of the various lighthouses along the coast. It found that the expenses of running the lighthouses added up to $23,222 during fiscal year 1860. It also noted the locales of these lights: "That the localities of the Light Houses & Beacons are as follows, viz. Georgetown, Cape Romain, Bulls Bay, Charleston, Morris' Island, Sullivan's Island, Fort Sumter, Castle Pinckney & St. Helena Bar, and the Light Vessel is on or near Rattlesnake Shoal, and that there are various Buoys, stationed at proper points, in the several harbors of the State." [35]

Despite having made so many strides in establishing safe navigation for mariners, there was no way the lights could remain lit in the face of impending invasion. The defenders of Charleston made the decision to destroy the city's valuable lighthouse. A contemporary newspaper account noted that the lighthouse was destroyed in December 1861: "A report reached this city yesterday morning that the Charleston Lighthouse, situated on Morris' Island, and which for many years has guided the mariner to our harbor, was blown up on Wednesday night by order of the military authorities. Only a heap of ruins mark the spot where it stood." [36]

THE GEORGETOWN LIGHTHOUSE

G eorgetown has a rich maritime history dating back over three hundred years, as the town developed into an important shipping point for people of the Carolinas. Winyah Bay, where the Pee Dee, Black, Sampit and Waccamaw Rivers converge, provided a transportation outlet for the people of both North and South Carolina. Valuable commodities such as rice, indigo, cotton, naval stores, tobacco and sugar made this one of the most important ports in the South, and ships from all over the globe visited the bustling port of Georgetown.

The need for a lighthouse marking the entrance to this important harbor came shortly after the end of the American Revolution. Information is sketchy, but evidence indicates that there was some effort on the part of local officials to establish a lighthouse at Georgetown just prior to when the federal government took responsibility for the states' aids to navigation in 1789.

Congress appropriated $5,000 on February 21, 1795, to build a lighthouse at the entrance to Winyah Bay. Later that year, Paul Trapier donated a seven-acre tract on North Island for the erection of the lighthouse. The money was re-appropriated, plus an extra $2,000, toward completion of the structure in March 1798. The total price for construction of the Georgetown Lighthouse was $6,893.[37]

According to early descriptions, the original Georgetown Lighthouse was a seventy-two-foot tall wooden structure built on North Island, on

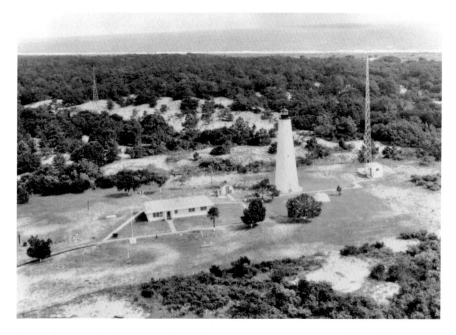

The Georgetown Lighthouse on North Island overlooks the entrance to Winyah Bay. *Photo courtesy U.S. Coast Guard Historian's Office.*

the north side of the entrance to Winyah Bay. The tower was mounted upon a brick foundation, measured twenty-six feet at the base and tapered to twelve feet at the top. The structure was covered with cypress shingles. Atop the lighthouse was the lantern room, which held an oil-burning cast-iron lantern with a diameter of six feet. The lighthouse was octagonal in shape and painted with red and white stripes.[38]

The Georgetown Lighthouse was lit for the first time on February 14, 1801. Unfortunately, the wooden lighthouse was not able to withstand the fierce weather that is often prevalent along the Carolina coast, and it stood overlooking the waters of Winyah Bay for fewer than six years.

One of the dangers facing a wooden lighthouse is fire. The combination of open flame, flammable liquids and high winds proved to be a dangerous mix that claimed many of the old structures. Georgetown's original lighthouse caught fire on at least one occasion. On December 4, 1804, port authorities advised mariners of the accident: "The Light-House, on the point of North Island,

Georgetown, South Carolina, by an accident, caught fire on the night of the 4th instant, and it is so much damaged as to prevent the light from being shewn [*sic*] until some repairs are made."[39]

What finally destroyed the Georgetown Lighthouse was not fire but a powerful hurricane that raged through the western Atlantic from the Bahamas to South Carolina in August 1806. After making landfall somewhere in the vicinity of Cape Romain on August 22, the storm's extremely high winds and tides brought destruction to the area between Georgetown and Cape Fear. This was the second particularly intense hurricane to strike the area in a two-year period.

An eyewitness to the storm wrote the following account, which was published in a North Carolina newspaper in September 1806: "I take the liberty to enclose you a notice of the Light-House on North Island having been blown down. The gale by which the accident happened was more severe than the one which took place in September 1804; fortunately there was but little easting in the wind, from which circumstance the rice crops have received but little damage, the tide not rising higher than it frequently does with the springs."[40]

The importance of Winyah Bay and Georgetown as a commercial shipping point meant that it was crucial to replace the lighthouse. By October, officials were scurrying to get the lighthouse at the entrance to Winyah Bay back in place. Charles Brown, who was in charge of the light, advertised for someone to build a replacement. "Any person willing to contract for building a light house, on North Island, wither of brick, wood, or stone, and to furnish every material considered necessary to complete it, for its particular use, will please to send proposals in writing, signed and sealed up, on or before the 1st day of November next, and directed to CHARLES BROWN of Georgetown, Superintendent of the Light House, on North Island. The Building must be 24 feet base, 80 feet to the summit of the brick, stone, or wood work, and 12 feet diameter."[41]

In February 1807, Congress appropriated $20,000 for construction of a replacement. The new light was to be built of a material more durable than wood. It would take over four years before the brick lighthouse was completed and operational. A plaque on the tower proclaims that it was completed in 1811, though there are other sources that claim the light was not put into operation until 1812.[42]

A decade later, in 1822, another fierce hurricane came ashore near Winyah Bay. The massive storm produced a storm surge that claimed the

lives of at least 300 people, with 125 drowning on North Island. Although the tempest tested the resiliency of the new Georgetown Lighthouse, the brick structure fared better than its wooden predecessor had during the 1806 hurricane, surviving the storm with only minor damage.[43]

Robert Mills made the following comments about the Georgetown Lighthouse in 1832: "The light house, which contains a stationary light, is erected on the south end of North Island, about 400 yards from the point. It stands in the latitude 33° 13' longitude 78° 55'. The elevation of the lantern above the sea is 89 feet. The lighthouse itself presents a white appearance. To enter Georgetown Harbor, bring the light to bear North half West. The channel is crooked and not safe for strangers."[44]

Upgrades were made to the Georgetown Lighthouse in 1838. Lighthouse Superintendent Thomas L. Shaw announced that the lighthouse at Georgetown was taken out of service until the modifications could be completed. He warned mariners, "The light at North Island Light House will be discontinued on the 18th inst. and will not be lit again before 5th Feb. for the purpose of putting on a new lantern and some other work necessary to be done."[45]

After the upgrades were made, the following description of the lighthouse on North Island appeared in the 1842 edition of Blunt's *American Coast Pilot*: "Georgetown light-house is a lofty circular white tower, and black lantern, erected on North Island, which is on the northern and eastern sides of the harbor, at the entrance of Winyah Bay, on a low sandy spit, and exhibits a fixed light, 90 feet above the level of the sea at high water, bearing N. $\frac{1}{2}$ W. from the entrance of the bar, 6 miles distant."[46]

Sometimes, captains confused the Georgetown Lighthouse for the lighthouse on Cape Romain. One example of this was the captain of the steamer *Atalanta*, who made such a mistake in the wee hours of the morning just after midnight on September 17, 1850. As the steamer was running in toward the coast, the captain and crew thought the light at Georgetown was the Cape Romain Lighthouse and that the light in the distance was the Charleston Lighthouse. They adjusted their course as if they were headed for Charleston Harbor. The sun still had not risen when they discovered their mistake by running up on the beach north of Cape Romain instead of sailing safely into Charleston. Fortunately, no lives were lost and the vessel suffered only minor damage. A steamer came out from Charleston and towed the damaged *Atalanta* into port for repairs.[47]

Plans were made in the 1840s for establishing another lighthouse at the mouth of Winyah Bay. The new lighthouse was to be established on South Island. Whether it was intended to act in conjunction with or replace the lighthouse on North Island is uncertain. Congress appropriated $5,000.00 for the South Island lighthouse in March 1847. However, difficulties with obtaining a suitable piece of land at a reasonable price derailed the project. The money was never spent on the South Island lighthouse, but by April 1856, $4,319.84 was spent on a set of range beacons on both North Island and South Island to be used in conjunction with the Georgetown Lighthouse.[48] In 1857, the Georgetown Lighthouse was modified to accept a fourth-order Fresnel lens. No modifications were made to the tower, so the appearance of the structure was little changed.[49]

Waterborne commerce on the inland rivers and creeks increased during the decade leading up to the War Between the States, mainly due to an increase in the timber and naval stores industry along the rivers upstream. Traffic increased to the point where it was desirable to have another lighthouse erected, this one several miles inland. The federal government appropriated $6,000.00 on August 18, 1856, for construction of a lighthouse on Fort Point. Work commenced in 1858 and was completed by 1859. The total price for construction of this lighthouse was $4,912.78, putting the project $1,087.22 under budget.[50]

On January 28, 1858, Captain W.H.C. Whiting, engineer for the Sixth Light House District, published a notice for proposals for construction of a lighthouse "upon the site of Fort Winyaw [sic] near Georgetown, S.C."[51]

Fort Winyah was the site of a fort built at the junction of the Black and Sampit Rivers during the War of 1812. Although some claim the site was eroded into Winyah Bay, archaeologists have identified most of Fort Winyah within the bounds of Morgan Park, between the baseball fields and the waters of the bay.

With the onset of the Civil War, Confederate defenders sabotaged most of the lighthouses along their coast in an effort to make sure they were of no use to the Union ships that were patrolling offshore. The lighting apparatus on the Georgetown Lighthouse was removed shortly after the outbreak of hostilities, but the tower itself remained standing.

When opportunity presented itself, Southerners used the brick tower as a lookout post to keep track of the Federal blockaders just offshore,

Fort Winyah stood at the head of Winyah Bay at the mouth of the Sampit River.

hoping to warn the local folks of any attempts by the enemy to enter Winyah Bay and raid Georgetown. But the Union navy was frequently in possession of North Island and the lighthouse and was able to land and occupy the site at will, at one point utilizing it as a camp for contraband, or runaway slaves.[52]

The Georgetown Lighthouse suffered extensive damage during the war, but the tower was still standing. According to local lore, Union gunners used the lighthouse for target practice. Two years after the end of the fighting, lighthouse officials once again found it necessary to effect major repairs on the structure. Once this work was completed, the whitewashed brick Georgetown Lighthouse stood eighty-seven feet tall. The stone stairway and support post still led to the top, where "a new fourth-order apparatus" was installed. At the same time, a new two-story house and kitchen were built on the site. The tower has remained in much the same condition to the present day, with only a few minor modifications.[53]

In the winter of 1986, the Georgetown Lighthouse was automated, and the long history of keepers manning the old light came to an end. The previous twenty years had seen the operations of the lighthouse change quite a bit. After a fire destroyed the keeper's quarters in 1968, the U.S. Coast Guard sent out crews of two to man the light for twenty-eight days at a time. They decided to change this somewhat in 1985

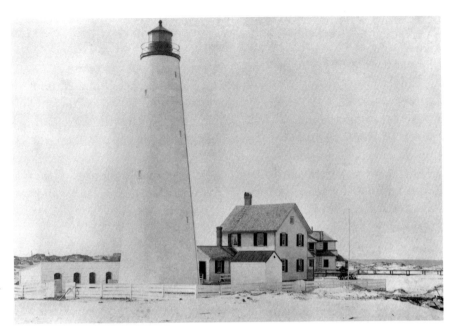

The Georgetown Lighthouse and keepers quarters are visible in this U.S. Lighthouse Service photo taken in 1890. *Photo courtesy U.S. Coast Guard Historian's Office.*

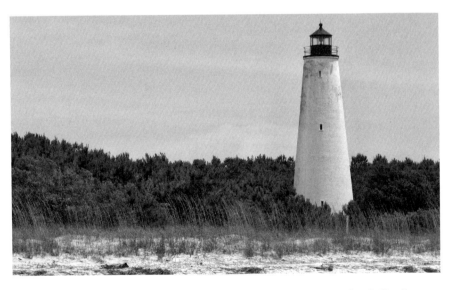

The Georgetown Lighthouse has been a prominent landmark along the South Carolina coast for more than two hundred years. *Courtesy of Bob Urban.*

by dispatching a two-man crew daily from the Coast Guard station in Georgetown, with one of the people remaining behind and spending the night at the lighthouse.

The following year, the Georgetown Lighthouse was fully automated. On February 26, 1986, a brief ceremony at the Belle Isle Yacht Club marked the automation of the Georgetown Lighthouse. Commander Steven Froehlich of the U.S. Coast Guard came up from Charleston to preside over the ceremony.[54]

As the twenty-first century begins, the historic lighthouse still stands and is an important part of the rich maritime heritage of the people of Georgetown and Winyah Bay.

THE CAPE ROMAIN LIGHTHOUSE

Extending into the Atlantic Ocean between Winyah Bay and Charleston, Cape Romain is the most prominent promontory along the South Carolina coast. Like other famous capes along the coast of the southeastern United States, including Cape Hatteras to the north and Cape Canaveral to the south, the sandy shoals of Cape Romain have claimed many wrecks. This was especially true in the days when wooden sailing ships plied these waters. Many hapless mariners found their vessels stranded on the remote, low-lying sandy islands.

During the eighteenth and early nineteenth centuries, there was no official aid to navigation between Winyah Bay and Morris Island to help navigate these sometimes dangerous waters, but mariners utilized a windmill that was built near the cape as a handy landmark. The low-lying island where the windmill was built is today known as Mill Island and once belonged to the Thomas Lynch family. In 1800, Captain Lawrence Furlong advised readers of his *American Coast Pilot*, "On Cape Roman is a Wind Mill which has frequently been taken for Charleston light-house."[55]

Exactly why people mistakenly identified the windmill for a lighthouse is uncertain. One would think that the large blades on the windmill would have made that structure one of the most easily recognizable landmarks along the coast. And this wasn't the only windmill along the Atlantic coast of the United States. Other windmills were generally much smaller than this one and easily distinguishable from a lighthouse structure.

Perhaps when the windmill was not in operation, such as when bad weather was threatening or there were no logs ready to be cut for an extended period of time, the operators of the mill would take the blades down and store them to protect them from the elements. With the blades removed, the remaining base of the windmill would have looked more like a tower and was more likely to be mistaken for a lighthouse structure. Whether its blades were visible or not, the windmill was the most visible structure along this stretch of low-lying coast, where the islands are little more than glorified sandbars. And many navigators who regularly passed along the coast came to rely on the windmill as an aid to navigation.

Not everyone appreciated the windmill. As a matter of fact, the structure became a hazard to navigation, owing to the fact that it was frequently confused with adjacent lighthouses, especially the one at Charleston. Many ships wrecked upon the beach and shoals near Cape Romain after their crews had mistaken the windmill for the Charleston Lighthouse and thus steered for what they believed to be Charleston Harbor.

The windmill at Cape Romain gained such a bad reputation with mariners along the coast that it was often the subject of many scathing remarks in the press of port cities along the eastern seaboard. One such piece of unflattering commentary came from the editor of the *National Advocate*, a newspaper published in New York City. "Several vessels have been wrecked and many accidents happened from mistaking the windmill on Cape Romain for the Charleston Light," wrote the editor in September 1816. "The loss of the *Diamond*, from Havana, is attributed to that cause. The safety of vessels and security of persons and property renders it necessary that something should be done to prevent accidents of like nature. It would be well to take down the windmill or erect a lighthouse; we think, however, if the windmill is removed, it would answer the purpose. At present, the similarity between the Charleston Light and the windmill is the cause of many unfortunate casualties."[56]

The ship to which the editor was referring was the Spanish schooner *Diamond* (or *Diamonte*, as she was also known), which wrecked off Cape Romain in the summer of 1816. Under the command of Captain Christoval Soler, the ship had sailed from Havana, Cuba, in July, bound for the coast of Africa. After a month at sea, the *Diamond* encountered

a ferocious storm on August 10 while passing in the vicinity of 29° N, 50° W. The storm tossed the ship around for five days, battering the vessel with fierce winds and monstrous seas. The ship sustained much damage, including loss of its masts. When the storm abated, Soler and his men made what repairs they were able and then set course for the nearest land, which he reckoned was somewhere along the southeastern coast of the United States in Georgia or the Carolinas.

The nearly disabled ship with its jury-rigged masts made its way as best it could, but the weather continued to be unsettled. Soon they were overtaken by a schooner from Philadelphia named the *Hornet*, under the command of Captain Anthony Hallman. The *Hornet* rendered what assistance it could, including sending over one of the passengers on board, Captain Edward C. Gardner, who was familiar with this part of the South Carolina coast and thus possibly able to help the Spaniards negotiate the tricky passage into Charleston Harbor.

Exactly what happened next is a bit hazy. For reasons not entirely clear, someone mistook the windmill at Cape Romain for the Charleston Lighthouse and directed that the *Diamond* steer for what he was sure was Charleston Harbor. Captain Soler protested that he did not believe they could be near Charleston yet. Upon receiving assurance from the mate that the lighthouse and other landmarks, such as the church steeples, were visible, Gardner directed the ship to proceed as if entering Charleston Harbor. Unfortunately, the mate was wrong, and the ill-fated *Diamond* soon grounded on the shoals off Cape Romain.

Fortunately, the *Hornet* was still nearby and able to help. Crews from both ships began transferring cargo from the *Diamond* to the *Hornet*, but the weather deteriorated and the *Hornet* was forced to cut the cables and move off away from the *Diamond*. "The last that was seen of the *Diamond*," reported the *City Gazette*. "She was firing great guns and musketry, as if in the greatest distress, and immediately after the lights in her rigging suddenly disappeared."[57]

The situation for the men on board the *Diamond* was made even worse by the fact that their longboat was still on the *Hornet*, along with the mate and five men from the *Diamond*. As their vessel continued being pounded to pieces by the heavy seas, the men on the *Diamond* fashioned together a raft out of planks and oars on their vessel. But this would-be life raft was unable to bear the weight of all the Spaniards, who jumped on it at the same time and destroyed the frail craft.

The Spaniards then abandoned their ship and took to the sea, grabbing hold of whatever they could find to help them stay afloat. Some used pieces of their makeshift raft, while others found boards or floating boxes. Before the ordeal was over, twenty-one men of the *Diamond*'s fifty-one-man crew were killed.[58]

Among the survivors was Captain Gardner, who spent over forty hours drifting about on the surface of the ocean until he was finally rescued by the crew of the pilot-boat out of Charleston. Gardner had been on the raft that had disintegrated and noted that the Spaniards took to the water to save themselves individually. He saw several of the crew go down beneath the surface, and he thought that Captain Soler was among them.[59]

As it turns out, Captain Soler survived. He spent several days floating on the ocean until being picked up by Captain James Hill and the crew of the wrecking boat that was coming out from Charleston to see if there was anything left to salvage from the wrecked ship. Soler told an interesting tale of his misadventures and the hardships he met with in the three days and four nights that had elapsed since his ship went down. But what immediately caught Hill's attention were Soler's claims that he had taken off his pantaloons and used them to help lash together some oars into a makeshift raft. The reason this was so intriguing to Captain Hill was because Soler claimed that he had sewn many valuable coins into the lining of his pants. They immediately returned for the raft, but just as they reached it, the valuable pantaloons sank to the bottom of the ocean.[60]

Soler later learned that there were several versions being bandied about regarding the shipwreck story. Wanting to make sure that his side of the story was told, he sat down on September 8, 1816, and wrote an account of the accident. This note was published widely in several newspapers across the country, helping to preserve an important firsthand account of the perils of nineteenth-century navigation and the high cost paid for mistaking a windmill for a lighthouse. Soler pins much of the blame on Captain Gardner, whom Soler and the officers of the Spanish vessel believed to be a pilot. Captain Hallman of the *Hornet* later claimed that he never said Gardner was a pilot, just a mariner familiar with those treacherous waters who might be able to help the stricken Spanish vessel find its way into Charleston Harbor.

Soler wrote of the incident:

Having made, on the 28th August, Cape Romain, being in 11 fathoms water and a schooner in sight, which appeared to us to be a pilot-boat, stood for and spoke her, and enquired for a pilot; they answered, we must send a boat to them, which was immediately done, She returned on board the Diamond *with Capt. Gardner, who told us that he was a pilot for all that coast. That there might be no mistake, I asked him again if he was a pilot, to which he replied, "Yes, yes—if you give me the command, I will carry you into Charleston." The vessel was then put at his command, when he ordered her to be kept away; and continued so until 3 o'clock in the afternoon, at which time we saw something which appeared to be a steeple or a tower. Capt. Gardner said he believed it was Charleston Light-House, but I said it could not be—he still insisted upon it. Shoaling our water, however, very fast, he ordered the vessel to be brought to an anchor. He then hoisted the colors and fired a gun. Finding himself locked in the shoals, Captain Gardner sent his small schooner to sound for a passage out over the shoals; she returned and reported that the tower they had seen was not Charleston Light-House. At the same time, the sea began to break very heavy from E.S.E. He ordered the anchor to be weighed, but I told him he had better not get under way, to which he replied that if we did not allow him to get the* Diamond *under way, he would depart for his own vessel. Finding my vessel in this disagreeable situation, and knowing that I could not extricate her myself, rather than be left to ourselves in a place with which we were entirely unacquainted, he was allowed to proceed as he thought proper. He then got her under way, and directly struck upon the bank, and sunk, as has already been stated. Captain Gardner, on his arrival in Charleston, supposing that I had been drowned along-side the wreck, and probably believing that no one would step forward to contradict his statement, has endeavored to exonerate himself from blame in the loss of the* Diamond *and throw it all upon me. But after drifting at the mercy of the waves for three days and four nights, I was providentially picked up by Capt. Jas. Hill, in his wrecking boat, on the 31st of August, when at the point of death; and I now declare upon my honor that the statements given of the causes which led to the loss of my vessel are not true.*[61]

Clearly, there were many factors that led to the destruction of the *Diamond* on that tragic summer day back in 1816; it was more than just

a mere case of mistaken identity. Communications on a windy, storm-tossed deck of a ship can be difficult. Add to this the fact that there may have been some mistakes due to the language barrier, though it is obvious that some of the Spaniards on board knew some English. What is not in doubt is the culpability of the windmill on Cape Romain, which once again lured a ship bound for Charleston mistakenly into the treacherous waters off the Raccoon Keys and Cape Romain.

Less than a year later, in 1817, Edmund Blunt included an ominous warning for the owners of the windmill: "We will also give a hint to the owner of the wind-mill, on Cape Romain, which has deceived many Navigators and caused a destruction of their vessels, and remind him that as there is a curse denounced against him who 'removeth his Neighbor's landmark,' we presume (and hope) a double one will be his who willfully holds out a false beacon to the mariner when approaching the coast."[62]

The situation became so serious that the government of South Carolina was finally compelled to take some sort of action to help look out for the safety of people traveling along the coast in the vicinity of Cape Romain. In November 1821, James Pringle of Charleston and William Chapman of Georgetown were appointed commissioners by the State of South Carolina to have some sort of daymark painted on the windmill so that people would not continue to confuse it with nearby lighthouses. The resolution noted, "They are hereby authorized on behalf of the State to affix a cross or some other such mark to the said building in order to prevent in future as far as possible the serious calamities which have happened to mariners and others from the contiguity and the resemblance of the said wind mill and the Charleston Light House."[63]

One anonymous wit even composed an ode to Cape Romain and its famous windmill that guided so many hapless mariners to their doom. The poem was copied by newspaper editors who included it in publications all over the country, not just in South Carolina. This designation of the windmill on Cape Romain as a "murderous beacon" was not something for which the people of South Carolina wanted to be known, especially those responsible for promoting such growing cities as Charleston and Georgetown.

CAPE ROMAIN

The breakers are foaming and dashing along,
The pelican sits on the wave;
The sea-gull and curlew are mingling their song,
With the scream of the winds as they rave.

The horizon discovers three desolate isles,
To life and to verdure unknown;
Save the rattlesnake, where in his malice he coils,
Or the myrtle in pity hath grown.

There are wrecks on the coast—there are bones on the shore,
And a murderer's beacon on high;
That invites him to enter, who goes forth no more,
And yields him allurement to die.

O'er passing in safety the perilous sea,
The mariner welcomes the land;
How short his illusion—how fatal his glee,
His corpse is ashore on the strand.

The day-star of mercy shall dawn on the scene,
And the signal of piety show,
Where the wreck of the innocent victim has been,
And guard the survivor from woe.

Ah! Who to a nation of freeman is dear,
If not the bright son of the wave?
When his home, and his wife, and his children grow near,
Oh! Beckon him not to his grave.[64]

Edmund Blunt gave a detailed description and instructions for how to properly and safely utilize this navigational aid:

A wind-mill is erected on the point of Cape Roman, which at a distance, having the appearance of a light-house, especially in hazy weather, will easily deceive strangers, who, from want of exact latitude in approaching

the coast, may mistake it for Charleston light-house. In falling in with this wind-mill, you must not come less than 7 fathoms water, bringing it to bear W.N.W. Then you are abreast of the Cape Shoals, and Charleston light-house will bear W.S.W. about 15 leagues. In consequence of its resemblance to the lighthouse, it has engaged the notice of the Legislature of South Carolina, who have passed a resolution appointing certain persons to fix a mark of distinction upon the building, to prevent the repetition of accidents to vessels on that coast.[65]

Congress appropriated $10,000 for the erection of a lighthouse on Cape Romain in 1823. At first, the planners hoped they would be able build a new lighthouse by making a few modifications to the old windmill and thus turning the familiar landmark into an official lighthouse. Upon closer examination, however, they found the site to be inadequate, and another site on Raccoon Key was chosen.

Controversy over ownership of the site chosen for the location of the lighthouse delayed construction for several years. Once these matters were finally cleared up, work proceeded rapidly on the structure. Work on the site commenced in March 1827.[66]

By April, the lighthouse was tall enough to be noticed by mariners passing through the area. Winslow Lewis was the principal builder, and he completed the structure for less than $7,500. A contemporary report from Charleston noted, "We have received information from the Captain of a regular coaster between this port and Georgetown that the New Light House on Rackoon [*sic*] Keys, near Cape Romain, has progressed so as to be nearly as high as the Wind Mill. We give this information for the benefit of Mariners generally. It is in such a forward state that it is probable it will be lighted up by the last of June or first of July."[67]

The following month, the U.S. revenue cutter *Gallatin*, under the command of Captain Matthews, made a trip along the coast between Georgetown and Charleston. After stopping by Cape Romain to check on how the work was progressing, Matthews was able to report back to the people in Charleston that the work was coming along well. He estimated that the light would be finished by the middle of May.[68]

On May 21, 1827, the aforementioned James Pringle, who was the collector of customs at Charleston, issued a notice to mariners announcing the completion of the work on the new lighthouse: "The Light House lately erected on the N.E. Raccoon Keys, near Cape Romain, will be

lighted on the 1ˢᵗ June next and every succeeding night (unless notice to the contrary is given). The Light is a Red Stationary Light. The latitude 33, 01 N. Longitude 78, 34 W. The Pitch or Southern Point of Cape Romain bears E.S.E. from the Light House. The Old Mill N ¼ W and the large Raccoon Key W by S."[69]

The tower from the old windmill remained in place for several years. The *Daily Phoenix* reported, "A remarkable landmark, the Mill Tower, in the vicinity of Romain Light-House, on Cape Romain Island, is reported as having been removed; by whom it is not known, but certainly much to the regret of masters of vessels, who ever regarded it as an invaluable nautical point. Tradition says it was erected far back in Colonial times, of Carolina brick, and that British vessels used to run to the mill for cargoes of lumber for the other side."[70]

Ambrose Mills provided an early description of the first official lighthouse at Cape Romain in his *American Pharos*: "This light house stands on one of the Raccoon Keys, near what is termed Cape Romain, in latitude 33° 02' longitude 79° 06'. The light is stationary, red and bright, and the lantern which contains it is elevated 87 ½ feet above the level of the sea. The light guides to no harbor but is intended to warn mariners of their vicinity to the shoals of Cape Romain, which lie E.S.E. from the light 8 or 9 miles. The light house is painted alternately white and black, beginning with white at the base and ending with black at the lantern."[71]

After ten years of service, the Cape Romain Lighthouse that Lewis built was a familiar landmark to travelers who passed along this stretch of coast. By 1842, Blunt was able to elaborate on his earlier descriptions of the light in his 1842 edition of the *American Coast Pilot*: "On Raccoon Keys, near what is termed Cape Roman, a light-house is erected, showing a fixed light distinguished by red and bright lights. It is elevated 87½ feet from the river, at high water. The intention of this light is to warn mariners of the approach to Cape Roman Shoals, which lie S.E. from it, 6 miles distant. The light-house is painted alternately white and black, beginning with white at the base and ending with black at the lantern. The pitch, or southern point of Cape Roman, bear S.E. from the light-house; the Old Mill N ½ W., and the large Raccoon Key W. by S."[72]

Lieutenant David D. Porter wrote a report to the U.S. Lighthouse Board in June 1851 about the lighthouses along the east coast of the United States from Sandy Hook, New York, to the Florida Keys. He did not have a favorable opinion of many of the lighthouses he

encountered along this section of coast, but he did find the lights along the coast of South Carolina to his liking. Porter mentioned the next lighthouse encountered after leaving Cape Fear was Cape Romain. Why he missed the light at Georgetown is unknown, but Porter was favorably impressed with the Cape Romain Lighthouse, which he called a "very good one." He also noted, "Towards morning it grows dim, either owing to the mists or for want of attention to trimming—likely the latter."[73]

The Cape Romain Lighthouse was listed as a fourth-order light in a report filed that same year. It was suggested that it be raised to 150 feet and given proper lighting capability to make it a first-order light. After examining the structure, lighthouse officials found it impractical to follow through with this suggestion.

Work began on a new lighthouse at Cape Romain in 1857. When completed, the new octagonal brick structure was 150 feet tall and carried a first-order Fresnel lens, visible nineteen miles to sea. The lighthouse went into operation on January 1, 1858.[74]

Once construction was completed, it was noticed that the new Cape Romain Lighthouse had been built out of plumb. As the foundation settled, the structure continued to list, causing some concern for its survival. But the structure has remained in place for over 125 years, having survived wars, hurricanes and earthquakes.

Shortly after the beginning of the War Between the States, Confederate defenders of the South Carolina coast destroyed the lighting apparatus of the Cape Romain Lighthouse to keep it from being of service to Union vessels. Flag Officer S.F. DuPont made the following observations about the lighthouse in a report filed on April 1, 1862: "The tower at Cape Romain is standing, but the lantern and iron railing at top were all broken and the apparatus itself ruthlessly destroyed, the blockading officer who landed under it having picked up the prisms."[75]

After hostilities ended, it was deemed desirable to put this important aid to navigation back in operation as soon as possible. Thus it was repaired and put back into service by 1866. Two years later, keepers discovered that cracks were appearing in the walls of the lighthouse, apparently related to the tower's settling out of plumb. At first, the keepers simply kept an eye on the cracks. But as the cracks continued to grow, lighthouse officials worried that the damage would turn into something much more serious.

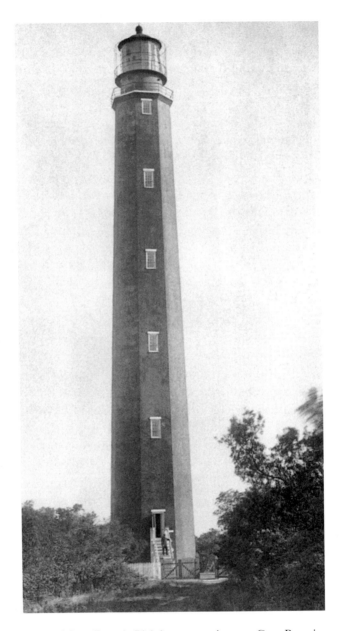

The second Cape Romain Lighthouse towering over Cape Romain.
Courtesy National Archives.

Concerns about the cracks in the Cape Romain Lighthouse made their way into the official 1873 lighthouse report. The damage could have potentially been bad not only for the new tower but also for the old one standing nearby. Lighthouse officials reported on the damage to the new lighthouse:

> *This tower is 150 feet high, built in the form of a frustrum of an octagonal pyramid, resting on a concrete foundation. In September 1868, it was discovered that slight cracks had opened on the north and south faces, in which the windows are placed. For a time, these openings remained as they were when first discovered; since then, additional cracks have opened on the westerly faces and the tower has settled considerably on that side—so much, in fact, as to require a re-adjustment of the lens. The deflection of the tower is now 23½ inches from the vertical and, in all probability, will increase; should it do so, the old tower will have to be replaced by a new one on a more secure foundation. Careful and frequent observation will be made to determine this fact.* [76]

The second lighthouse at Cape Romain remained a plain brick structure for nearly twenty-five years. According to the 1883 Annual Report of the Light-House Board, it was not "colored" until that year. This may have been the point in time when the lighthouse received its distinctive daymark consisting of a color pattern of black on top, white on bottom, with black stripe extending vertically from the top section nearly two-thirds of the way down to the base. The pattern was very similar to the color scheme employed on the original Cape Romain Lighthouse.

One of the most memorable occurrences for the lighthouse keepers stationed at Cape Romain Lighthouse was the great Charleston earthquake of August 31, 1886. The keeper was first disturbed by a loud noise that he likened to artillery and cavalry moving across a bridge. He later recalled, "In less than a minute came the shocks, the first one lasting about two minutes, the next one about as long, and about two minutes interval. Shocks, only a little less severe that the first two, were felt at intervals during the night. The shocks did the tower no injury, but its vibration was very great. It seemed a miracle that the tower and dwellings were left standing." [77]

In 1937, the Cape Romain Lighthouse was automated and the keepers removed. Ten years later, the lighting apparatus was removed.

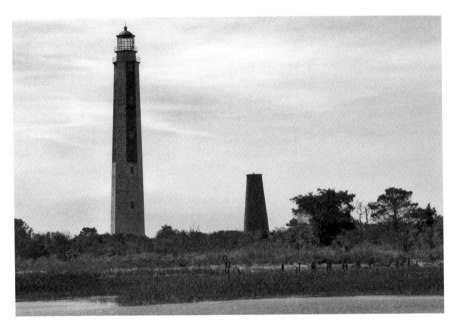

The Cape Romain Lighthouse in McClellanville, South Carolina. *Courtesy of Larry Myhre.*

Both lighthouses remain standing as prominent daymarks along the Intracoastal Waterway between Charleston and Georgetown. The old lighthouses are seldom visited today, but occasionally the staff of the Cape Romain National Wildlife Refuge, who administer the property upon which the lights stand, hold an open house for visitors to take a look at these historic structures that played an important part in the region's maritime history.

THE BULLS BAY LIGHTHOUSE

Bulls Island is a five-thousand-acre barrier island located in the Cape Romain National Wildlife Refuge, which lies between Charleston and Georgetown. Separated from the mainland by three miles of creeks and tidal marsh, the remote island is accessible only by boat, much as it has been for hundreds of years. This isolated place is an important locale along the coast between Cape Romain and Charleston, and few who visit this place realize that this lonely island has been the home to two lighthouses.

On January 21, 1851, P.H. Hammarskold surveyed a ten-acre tract on the eastern end of Bulls Island that had been selected by Napoleon Cost of the U.S. Revenue Service in Charleston as the site upon which to build a lighthouse for Bulls Bay. The tract was owned by Charles Jugnot, who was paid $200 for the land. It is interesting to note that Bulls Island was also referred to as Onesicaw Island in the deed conveying the property.[78]

The original lighthouse and keeper's quarters were constructed by Francis Gibbon of Baltimore, who built the structure in the summer of 1852. Total price was $4,150. The structure consisted of the keeper's quarters, on the second floor of which was located the lighting apparatus. The light was thirty-nine feet above sea level and visible up to twelve nautical miles.[79]

Shortly after the lighthouse was completed, a description of the new structure appeared in the 1854 edition of Blunt's *American Coast Pilot*, which

Plat of Bulls Bay tract purchased for construction of the light station, 1857. *Image courtesy National Archives.*

gave the following directions to mariners utilizing this new landmark: "Bull's Bay is about 23 miles northwest of the Charleston light. On the east end of Bull's Island there is a fixed light. Bring the lighthouse to bear N.W. ¼ W. by compass and run for it until over the bar, then follow the beach round by the lead until the point of the island gives you a harbor. This course will give you not less than 9 feet at the bar at low tide. Rise of the tide is about 6 feet."[80]

As with other lighthouses along the southeastern coast, the Bulls Bay Lighthouse did not fare well during the War Between the States. In April 1862, Flag Officer S.F. DuPont reported that the lighting apparatus had been destroyed by the Confederates and "everything recklessly broken, down to the oil cans, etc." But the structure remained an important landmark for ships of the Union blockading fleet, which often utilized it as a rendezvous point along this remote and often hostile stretch of coast.[81]

In the early days of the conflict, Confederate defenders constructed a small defensive work approximately fifty yards from the lighthouse on Bulls Island. Acting voluntary lieutenant J.F. Nickels, commander of the USS *Onward*, made a reconnaissance of the entrance to Bulls Bay between April 2 and 4, 1862, and had his ship fired upon by small-arms fire from the island. Nickels returned on April 7, 1862, and, taking up a position approximately four hundred yards from the lighthouse, bombarded the small earthworks. Afterward, he sent a landing party to capture the place. After putting up only a token resistance, the defenders fled, leaving Bulls Island to the Union navy. In his report, Nickels notes that the operation was a success but that it was "too late to prevent them from escaping to the mainland from the opposite side of the island in boats, setting fire to a house in their hasty flight, which we discovered to belong to W.II. Whilden, the former keeper of the light house."[82]

This was not the only military encounter on Bulls Island. Another occurred on March 9, 1864, when several ships carrying a joint army-navy task force rendezvoused off Bulls Bay Lighthouse. Colonel Gurney commanded a landing party that found the island deserted. Their purpose accomplished, they returned to their ships and went back to Charleston.[83]

After the end of the war, the federal government worked to repair and put back in operation many of the lights that had been extinguished during the conflict. The damage to the lighthouse at Bulls Bay was

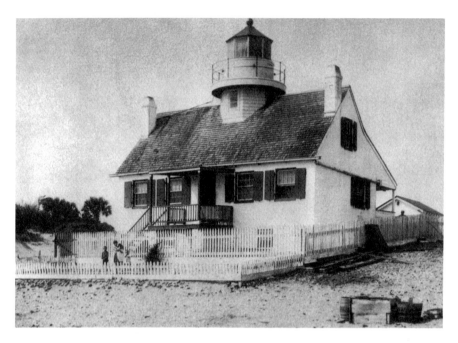

This photo of the Bulls Bay Lighthouse was taken by Henry Bamber in 1893. *Photo courtesy National Archives.*

repaired, and the lighthouse went back into operation in the summer of 1868.[84]

The sea relentlessly ate away at the beachfront site, and by the 1890s, it was obvious that the lighthouse's days were numbered. The Annual Report of the Light-House Board for 1897 explained the situation: "The erosion of this site by the sea continued until the southeast corner of the building which carried the tower was undermined, and there was danger that the whole structure would be washed down, with the loss of the apparatus. Hence the light was discontinued and valuable parts of the house and the illuminating apparatus were taken to Charleston, SC."[85]

Once it was realized that they were unable to stop the erosion, the light was officially discontinued on November 14, 1896. Three months later, on February 24, 1897, the remains of the first Bulls Bay Lighthouse washed into the ocean.[86]

In April 1897, Assistant Engineer B.B. Smith was dispatched to locate a tract of land on Bulls Island where a new lighthouse could be erected. Smith chose a ten-acre tract a short distance north of the

old lighthouse site. The proposed site was located on a more elevated part of the island that was farther inland from the beach and thus less likely to fall victim to the sea. This particular parcel of property belonged to Caroline Avinger of Charleston, who sold the site to the U.S. government for $500 on July 7, 1899.[87]

The new Bulls Bay Lighthouse was almost identical to its predecessor. In the spring of 1900, the metalwork for the new lighthouse was cast by the West Side Foundry of Troy, New York. The lighting apparatus from the old light, which was still in storage in Charleston, was brought out and installed in the new structure, which was ready for operation by 1901.[88]

The lighthouse next became victim to the change in patterns of transportation of the lumber and naval stores along the bay and its tributaries. As shipping into Bulls Bay decreased, the importance of the lighthouse diminished. It was finally decommissioned in 1913.[89]

The Bulls Bay Lighthouse and the ten-acre tract upon which it stood were sold at auction for $1,200. Francis Harrison of New York City purchased the property on March 14, 1914.[90]

The ultimate fate of the second Bulls Bay Lighthouse is somewhat of a mystery. Local tradition maintains that it suffered the same fate as its predecessor and washed into the sea.

THE FORT SUMTER RANGE LIGHTS

Fort Sumter is one of the most recognized landmarks in the United States. Virtually every schoolchild in America is taught that this was the spot where the opening shots of the Civil War were fired. Very few students of history realize that Fort Sumter has a special place in the Palmetto State's lighthouse history, as it was home to a lighthouse that, for many years, guided boats into Charleston Harbor.

In 1855, the U.S. Light-House Board began work on a lighthouse atop Fort Sumter. The light was finished by the spring of 1856, at which point Captain George Cullum of the U.S. Army Corps of Engineers provided a "Notice to Mariners" with the following particulars about the new light: "A fixed light of natural color was exhibited for the first time on the evening of 15th of May, 1856, on Fort Sumter, Charleston Harbor, South Carolina. The illuminating apparatus is of the fifth-order Fresnel Lens, placed in a lantern on top of a brick tower just within the north angle of the outer wall of the fort, and having an elevation of 56½ feet above low water. The arc of illumination is but 270°, and therefore no light will be seen on the shoal water behind Fort Sumter, and Fort Johnson and Morris Island; but in front of Fort Sumter all navigable waters from Morris Island around to Fort Johnson will be well illuminated."[91]

The early history of this lighthouse and how it came to be established on a military reservation was soon forgotten. Looking back through his files in November 1928, H.L Beck, superintendent

of lighthouses in Charleston, hunted for information concerning the origins of the light and came up with the following meager details: "Fort Sumter Light Station is on a military reservation. There is no record in this office of a permit from the War Department authorizing establishment of the station. Apparently a light has been maintained since 1855. There is no drawing or sketch of any kind in this office that shows the layout of this station."[92]

The first Fort Sumter range light was destroyed during the bombardment of Fort Sumter in the opening days of the Civil War. The Confederate defenders of Charleston Harbor who occupied the fort did not reestablish the light, lest it should act as a convenient target for Union gunners or as a handy navigational aid to ships of the Union navy.

After the fall of Charleston in the winter of 1865, Charleston Harbor became an important point for shipping along the coast for both the Union's army and navy, so the Federal government wasted little time in reactivating a light on the remains of Fort Sumter. Photographic evidence indicates that a lighthouse was in place as early as 1865, soon after the Union occupation of the city in the closing days of the war. This is alluded to in a statement found in the Annual Report of the Light-House Board for 1865, which described the aids to navigation into Charleston Harbor at the end of the war in the following terms: "The approaches to Charleston were lighted immediately after the occupation of that place by United States forces, but it was found, upon examination, that an almost total change had taken place, leaving no channel in the harbor as it was in 1860, and opening new ones. Under this altered state of things it became necessary to establish lights temporarily at such places as would be useful guides through existing channels."[93]

Later in 1865, a steel tower was built in Portland, Maine, and shipped by boat to Fort Sumter, where it was installed to be used as a frame for the light, which instead of a Fresnel lens, utilized a light from a steamer. On March 27, 1866, a fifth-order Fresnel lens replaced the temporary light. A new lighthouse was constructed to house the light. This served until 1872, when District Engineer Peter Hains reported that a new beacon had been erected at Fort Sumter in April.

The Fort Sumter light was rattled by the violent shocks of the Charleston earthquake of 1886. The lighthouse itself was unharmed, but some of the structures on the island suffered damage. The keeper noted, "The first shock lasted about forty-three seconds and later ones from three to

five seconds. One chimney was overthrown, and the frame houses were badly shaken. The first severe shocks came with a decided jar, were succeeded by a tremulous motion, and appeared to come horizontally."[94]

Waves generated by the winds and storm surge of the ferocious Great Sea Islands Hurricane in August 1893 washed over much of Fort Sumter. Although the massive masonry structure survived, the lighthouse and related structures that stood on the berm outside the fort were carried away by the storm. Lighthouse keeper Thomas Britt and his family were not able to get off Fort Sumter ahead of the deadly tempest and were forced to ride out the storm on the exposed island at the mouth of Charleston Harbor. By 7:30 p.m., as the winds increased and the waters rose, they left the keeper's quarters and sought refuge with seven other people in one of the powder magazines in the fort. A few minutes after reaching the fort, Britt saw the lighthouse and quarters carried away into Charleston Harbor by the winds and storm surge.

After the storm was over, the survivors spent more than two days with hardly any fresh water to drink until they were rescued by the *Pharos*, a lighthouse tender ship that had nearly been wrecked in the storm farther down the coast. Sergeant Britt later recalled his harrowing experiences at Fort Sumter that evening: "We were taken from the fort with the clothes on our backs. Look at me: here is a worn-out suit, and that is all I have to my name. But the worst of all was that we had only a half a bucket of water from Saturday noon until the time we were taken away. This had to do for eight of us, and when I got aboard the *Pharos*, I felt as if I could drink a whole bucket of water. The fury of the storm might be realized when it is known that two eight-inch Parrott rifles were overturned and buried in the sand. I never want to go through such a thing again. Just imagine life in a powder magazine for thirty-six hours; but we were all glad to be away living."[95]

For over two decades, from 1893 until 1915, vessels approaching the tricky harbor entrance lined up the Fort Sumter light with a light that shown from the steeple of St. Philip's Church in downtown Charleston. The alignment of the two lights indicated that it was time for mariners to adjust their course into the Folly Chute Channel.

St. Philip's Church is one of Charleston's most hallowed landmarks. Sometimes referred to as the "Westminster of South Carolina," the church's history stretches back into the seventeenth century. The current structure has seen much history since it was completed in 1834 and has

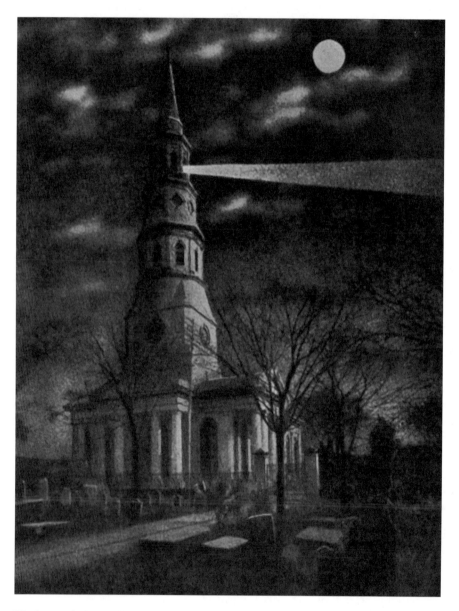

The beacon is shown shining from the St. Philip's Church in this circa 1900 postcard.

survived several calamities, both natural and man-made. The historic old church even has the distinction of having served as an official aid to navigation that guided mariners into Charleston Harbor. The light in the steeple of St. Philip's Church was officially established in 1893. For the privilege, the U.S. Light-House Board paid the church an annual rent of $300.[96]

Charlestonians were proud to point out the fact that their city was home to the only church in the United States that also served as an official aid to navigation. The city's chamber of commerce noted that it was one of only two such lighthouse arrangements in the world.

Despite its advantages, the St. Philip's Church Light had some serious drawbacks as an aid to navigation. On clear days and evenings, it made a good range light when used in conjunction with the Fort Sumter light. But most of the time, the light and the steeple on the church were not visible from the harbor entrance due to fog and haze.

In 1911, several ships' captains signed petitions being circulated by the Pilot Commissioners for the replacement of the steeple light with a gas-powered beacon erected farther out in the channel and closer to Fort Sumter. Their complaints with the light noted, "In going out, the St. Phillip Light is so far and located in the City, where smoke and haze shuts it out, and is lost to view sometimes before reaching this dangerous point or turn in the Channel."[97]

Not all mariners were in favor of abandoning the light in the church. On June 15, 1914, C.A. Cavileer, master of the SS *R.M. Thompson*, a vessel owned by the Philadelphia New Orleans Transportation Company, wrote a letter to Lighthouse Service officials in Charleston. He was responding to solicitation for input on proposed changes to the aids to navigation in Charleston Harbor, including the St. Philip's Church Light. Cavileer wrote, "The St. Phillip's Church light, being about three miles in rear of the Fort Sumter light, makes a very sensitive range; that is, if the ship or vessel varies from the channel it is readily detected, owing to the great distance between the two lights. The Gas Buoy No. 9 at junction of main channel and Mt. Pleasant Range is in line with the Fort Sumter and St. Phillip's Church lights, thus making three lights in range, and in land fogs and stormy weather is used as a guide when the St. Phillip's light cannot be seen." He went on to recommend that instead of being discontinued, perhaps it would help if the candlepower of the St. Philip's Church and Fort Sumter lights could be increased.[98]

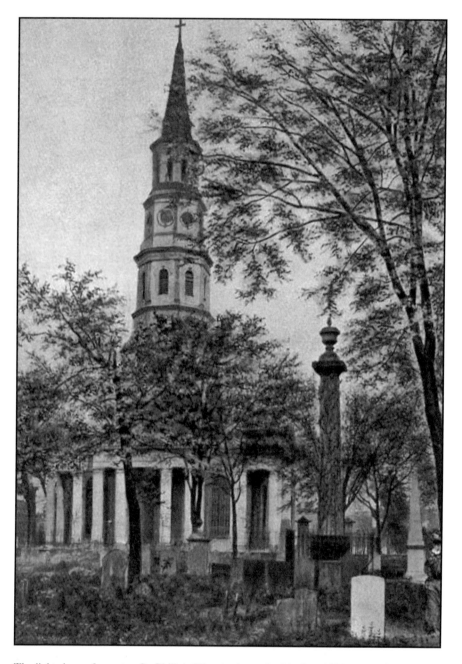

The light shown from atop St. Philip's Church, shown in this circa 1900 postcard, was a point of pride to Charlestonians as it made their church an official aid to navigation.

More ships' masters and bar pilots joined in the call for a new light. Even the city's chamber of commerce gave its reluctant approval. On June 2, 1914, W.D. Porcher, chairman of the chamber's River & Harbors Committee, wrote, "If the demands of navigation require the sacrifice, however, the committee sees no other reason for failing to endorse the proposed change. They will appreciate your giving the above sentimental objection your consideration before taking final action."[99]

In July 1914, the U.S. Bureau of Lighthouses officially authorized the discontinuance of the St. Philip's Church Light as soon as a new Fort Sumter light could be put in operation. The St. Philip's Church Light was taken out of service in 1915.[100]

The total savings realized for the discontinuance of the light in the church came to nearly $500, for in addition to the $25-per-month rental fee, they saved the salary paid to the "Laborer in Charge of Main Channel Range (St. Philip's Church) Light." The individual holding that position was John I. Whitney, who was paid $180 per year as keeper of the light in St. Philip's Church.[101]

The light on St. Philip's Church was briefly placed back into service six years later. The steamship *Cliffwood* collided with the Fort Sumter Range Front Light on January 30, 1921, knocking that light out of commission. In order to maintain a set of range lights for the entrance to Charleston Harbor until repairs could be made, it was necessary to temporarily re-establish the St. Philip's Church Light. This arrangement lasted less than a year, as the front Fort Sumter range light was rebuilt and put back into service in July 1921.[102]

Due to construction work on barracks at Fort Sumter in the fall of 1917, it became necessary to move the keeper's quarters twenty feet to the northeast. Lighthouse inspector H.L. Beck did not object to the move so long as the $500 expenses came out of the War Department's budget and not that of the U.S. Bureau of Lighthouses.[103]

On April 1, 1933, the lighthouse on Fort Sumter was automated and the keeper transferred to the Cape Fear Lighthouse. At the same time, lighthouse personnel were also removed from Fort Moultrie and the lights on Sullivan's Island.[104] Later that year, the lighthouse became home to a radio beacon, which at that time was the latest marvel in navigational technology. Commissioner of Lighthouses G.R. Putnam explained in a letter dated March 30, 1933, why Fort Sumter was chosen as the location for the radio beacon: "The Bureau considers that Fort Sumter is the most

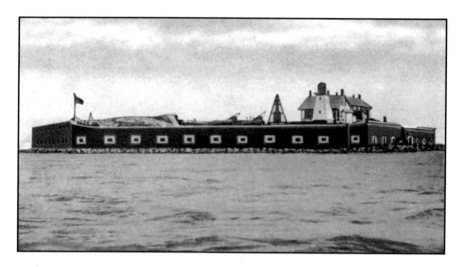

The lighthouse on Fort Sumter is shown on this circa 1920 postcard.

desirable location for the radio beacon when the lightship is removed. This radio beacon is primarily a harbor aid and, at this location, will serve best as a leading mark. The location of the radio beacon at the Charleston depot or elsewhere in the city is objectionable because of the possible wave distortion by buildings and power lines, also owing to possible harmonic radiation which might disturb local broadcast reception. The Charleston lighthouse is not favored because of its location, and because of coast erosion and other reasons, it may be discontinued."[105]

According to the National Park Service, the remains of the Fort Sumter Range Lights stood until they were demolished in 1948. Today, the historic fort where stood so many aids to navigation is the focal point of one of the National Park Service's most popular parks.

SOUTH CAROLINA'S SCREW-PILE LIGHTHOUSES

The Combahee Bank Lighthouse and the Fort Ripley Shoal Light Station

Ascrew-pile lighthouse was usually a wooden tower erected atop iron, stilt-like legs. The bottoms of these legs were fashioned into the shape of a corkscrew, which could be turned into the sandy bottom of sea or sound, securing the structure in place. The main advantage to this versatile design was that the lighthouses were lightweight and relatively inexpensive to build. The drawback was that they were usually less durable than other types of lighthouses, such as masonry structures. Following the War Between the States, the Lighthouse Board adopted this design for most of its lighthouses on inland waterways and sounds. Two of these structures were located in South Carolina.

A screw-pile lighthouse was built in 1868 to mark a treacherous sandbank at the head of St. Helena Sound known as Combahee Bank. This ill-fated lighthouse stood for only six years before it was undermined by the shifting sands at the bottom of the sound.

Details of the lighthouse are sketchy. We do know that it was not the first aid to navigation marking this dangerous spot. In March 1859, Captain Whiting of the U.S. Army Corps of Engineers mentioned that a lightship was to be repositioned here: "After June 30 next, the St. Helena bar light-vessel will be discontinued, and after she has been repaired she will be placed on Combahee Bank, St. Helena Sound. Due notice of the time of placing her will be given."[106]

By 1876, the lighthouse was in such bad condition that it had become a hazard to those manning the structure. Lighthouse officials soon ordered the structure be abandoned. The Lighthouse Board's report of that year noted, "The shoal on which this lighthouse was built has been washed away to such an extent as to endanger the safety of the structure and render it useless to navigation. The board, therefore, ordered the discontinuance of the light and the removal of the lens and lantern. The order was carried into effect June 30, 1876, the building remaining as a daymark."[107]

The light keepers were removed and the lighting apparatus taken away, but the screw piles and other parts of the structure remained in place, left to the mercy of the elements. Five years after being abandoned, the remains of the lighthouse were nearly destroyed by the winds and waves of a fierce hurricane. "The abandoned lighthouse on Combahee Bank, St. Helena Sound, was blown over and the northern half blown away, " reported the August 31, 1881 *New York Herald*.[108]

What remained of the lighthouse continued to deteriorate and, in less than a decade, fell into the waters of St. Helena Sound. The iron pilings remained in place and became a hazard to navigation. Local pilots advised of the hazard: "From its western point, the bank [Combahee Bank] turns to the northward to the southern point of Hutchinson's Islands. Both extremities are marked by buoys which will be described, and about a mile from the extremity lies the remains of the old Combahee Bank Light-house. It was an iron screw-pile structure, standing in six feet of water, but the current undermined its foundation, causing it to be abandoned, since which time it has fallen. A few of its iron piles still remain in sight."[109]

The Palmetto State's second screw-pile lighthouse went into operation in 1878. Instead of marking some lonely remote shoal, this structure was built to help guide ships through the state's busiest port.

In 1875, the Lighthouse Board proposed the construction of a screw-pile lighthouse on the Middle Ground between the Folly Island and South Channels to replace an older beacon that stood on Castle Pinckney. This earlier aid to navigation—the lighthouse on Castle Pinckney—had gone into operation on May 15, 1856. Captain George W. Callum of the U.S. Army Corps of Engineers described the light in the following terms: "The illuminating apparatus is of the fifth-order Fresnel Lens, placed in a lantern on top of an open frame 18 feet square

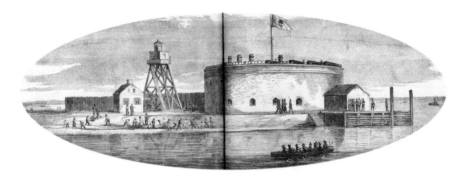

The lighthouse on Castle Pinckney is visible in this sketch made during the opening days of the War Between the States. Published in *Frank Leslie's Illustrated Newspaper*, January 26, 1861.

at bottom, and 10 at top, situated 100 feet to the northwest of Castle Pinckney. The woodwork is painted yellow, except the cylindrical part immediately beneath the lantern of four feet in height, which is a dark brown. The arc of illumination is 350° and the height of the light 50 feet above the water."[110]

The Castle Pinckney light was destroyed during the war. Soon after the end of the fighting, Congress appropriated $2,000 for rebuilding the light, but it was decided to abandon that idea in favor of building a new screw-pile lighthouse on Fort Ripley Shoal. The Castle Pinckney site would be used as a depot for the Light-House Board to store supplies.[111]

Fort Ripley was one of the defensive fortifications built by the Confederates during the War Between the States. Confederate engineers planning Charleston's defenses placed two cannons on a defensive work built on a section of shallows known as the Middle Ground, between Folly Island Channel and South Channel. The work was described as "a cribwork of pine logs, faced on the outside with palmetto logs." This humble work was given the grand name of Fort Ripley, in honor of General Roswell Ripley. There is no record of any battles having been fought at this site, though its guns were fired periodically at the Union forces besieging Charleston.[112]

Congress appropriated $15,000 for the fiscal year 1876–77 to construct the light near the site of Fort Ripley. This was followed in the fiscal year 1878–79 with another appropriation of $5,000, bringing the total for the construction of the Fort Ripley Shoal Light to $20,000.[113]

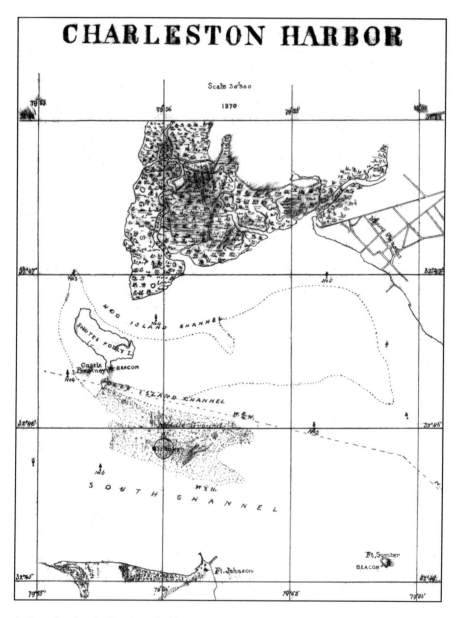

A chart showing the location of aids to navigation in the vicinity of Castle Pinckney in 1870. *Courtesy National Archives.*

Several parties involved claimed jurisdiction over this particular spot under Charleston Harbor, including the State of South Carolina and the City of Charleston. In March 1877, Governor Daniel Chamberlain officially ceded to the United States South Carolina's interest in the proposed site. On June 5, 1877, Charleston mayor George Cunningham signed over the title to "a submarine tract or parcel of land situated in Charleston Harbor, in the shoal known as 'Middle Ground.'" The South Carolina attorney general approved the deal in October 1877.[114]

Work commenced in 1877, but the delays led to cost overruns, necessitating the further appropriation in June 1878 of $5,000. The metalwork was cast in Cold Springs, New York, by a company called Paulding and Kemble, which had been awarded the contract in July. Its contract was revoked, however, once the ironwork was delivered to South Carolina and engineers deemed the pilings to be insufficient. Perhaps the lighthouse officials in South Carolina had learned a lesson about the resilience of questionable craftsmanship with the state's other screw-pile lighthouse. A contract was then awarded to a company from Wilmington, Delaware, called Pusey & Jones. The company recast much of the metalwork and installed the pilings for the lighthouse. With the project back on track, the Light-House Board hoped to have the light operational by November 1878.[115]

The Fort Ripley Shoal Middle Ground Lighthouse went into operation on December 1, 1878. A note in the 1879 report of the U.S. Light-House Board says of this structure, "The light-house stands about 500 feet southeast of the old foundation of Fort Ripley, in 8½ feet of water. It is a hexagonal structure, resting on one central and six periphery piles on wrought-iron ties and braces, in two systems, the lower being vertical

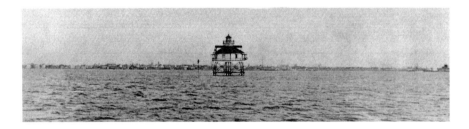

The Fort Ripley Shoal Light, shown here in 1896, was one of two screw-pile lights built in South Carolina. *Photo courtesy U.S. Coast Guard Historian's Office.*

and the upper inclined. The station is fitted with a fog-bell, struck by machinery at intervals of ten seconds."[116]

In January 1915, the official name for this station was shortened to Fort Ripley Shoal Light Station. The reason was straightforward, as noted in a December 28, 1914 letter from the acting commissioner of lighthouses in Charleston: "Chart No. 431 shows that Fort Ripley Shoal (Middle Ground) Light Station is not on the Middle Ground proper, but on a shoal to the southward thereof."[117]

On August 25, 1932, H.L. Beck, superintendent of lighthouses in Charleston, recommended that the Fort Ripley Shoal Light Station be discontinued and replaced with a buoy. He wrote that his reasons for ending the service of this structure were "economy and efficiency. It will provide a better aid than Fort Ripley Shoal Lighthouse and permit the latter to be discontinued in the interest of economy."[118]

Beck's suggestion was approved in September 1932, and shortly thereafter, the lighthouse on Fort Ripley Shoal was replaced by the Lower Middle Ground Lighted Bell Buoy. There is no sign of the historic lighthouse today, and most have forgotten the screw-pile structure that once stood watch over Charleston Harbor.

THE HUNTING ISLAND LIGHTHOUSE

The Hunting Island Lighthouse is one of the most recognized landmarks along the South Carolina coast. Throngs of tourists line up to visit this historic structure, where they are able to do something that they cannot do anywhere else in South Carolina—climb to the top of an official lighthouse. Even if this picturesque structure were not open for climbing, it would still be a place worthy of visits by those with an interest in the lighthouse history of the United States, as it is one of the few remaining cast-iron portable lighthouses ever built.

The reason a lighthouse was built on Hunting Island (or the Hunting Islands, as they were sometimes called) was because of the importance of St. Helena Sound, which carries the waters of four rivers to the Atlantic Ocean via an inlet between Edisto Island and Hunting Island east of Beaufort. For over four hundred years, it has been an important harbor. Today, the Intracoastal Waterway traverses the sound.

Another reason to mark this stretch of coast was that despite being between two important harbors (Charleston and Savannah), this was a remote place where many a mariner found himself uncertain of his exact location on the coast. The problem was exacerbated by the fact that wreckers sometimes illuminated lights along the beach of these islands to fool mariners into thinking they were somewhere else and thus luring them onto shore and leading them to wreck their ship. Sometimes the problem became so bad that notices of these "false lights" were posted to warn

mariners not to be fooled into the trap. For instance, in the summer of 1824, a rather elaborate light being shown from Hunting Island was seen by the crews of many ships. "Lights have been seen by several Captains of vessels, bound to this port, on the South Hunting Island, one elevated above the other precisely resembling those of the light house and beacon on Tybee," wrote a correspondent from Savannah. "So complete is the deception that the brig *Frances* lay to a whole night, under the belief they were the latter. Capt. Read, of the schooner *Barracoa*, from Baltimore, also saw them. As these lights can only be placed for an evil purpose, it is proper that those who exhibit them should be ferreted out."[119]

There were attempts to mark this important stretch of coast in the first half of the nineteenth century. One of the more intriguing reports concerning erecting a lighthouse to mark the entrance into St. Helena Sound was the result of an investigation that occurred in the winter of 1838. Several parties were dispatched by the U.S. Navy to make a thorough study of the St. Helena Sound and adjacent waters, with an eye to erecting various aids to navigation. One of the surveying parties, consisting of Commander John Rodgers and assistants J. Petigru and D. Ingraham, submitted a report specifically commenting on the desirability for building a lighthouse and other structures and specific points around the sound. The report noted:

> St. Helena is the outlet for a great deal of produce which comes down the rivers that form St. Helena Sound; consequently, the navigation is very considerable. At present, there is nothing to mark either the entrance or channel. After collecting all the information we could at Beaufort, and examining the bar and channel, we have the honor to report that, in our opinion, the following works are required, viz: A light-house on Otter Island, forty-five feet high; a light-boat in the sound, between Morgan Island Spit and Combahee Point Spit (these points extend a long way down and cannot be marked by lights on shore); a frame beacon on Marsh Island, thirty feet high; a buoy on north breaker of Main Channel; a buoy on Overall Channel; a Buoy on Eggbank Shoal; a buoy on Pelican Shoal; and a buoy off the shoal that extends from Marsh Island to Morgan Island. When these are completed, the navigation to good anchorage in the Inlet of St. Helena will be completely safe and secure.[120]

In 1851, the U.S. Lighthouse Establishment recommended that a first-order coastal lighthouse be constructed at the mouth of the sound on the north end of Hunting Island, but it was not until August 1854 that Congress authorized construction of a lighthouse at Hunting Island.

In 1856, $30,000 was appropriated by the U.S. Congress for building what was described as "a lighthouse and beacon light on the north point of Hunting Island, to serve as a sea-coast light and range for the Swash Channel in place of the light-vessel at present stationed off St. Helena, and for repairing that vessel at Combahee Bank, in the State of South Carolina."[121]

Work progressed slowly on the light. In 1856, $7,282.80 was spent on construction of the lighthouse, with the remaining $22,717.20 being spent the following year. The lighthouse went into operation in the winter of 1859.[122]

Captain W.H.C. Whiting of the U.S. Army Corps of Engineers issued an official notice to mariners from Savannah, Georgia, on March 8, 1859. It described the first Hunting Island Lighthouse in the following terms: "The main light-house is a conical tower built of reddish gray brick, the upper 25 feet of which will be colored white. The tower is surmounted by a brass light. The illuminating apparatus is a lens of the second order of the system of Fresnel, showing a revolving light of the natural color, the interval between the flashes of which is 30 seconds. The tower is 95 feet high, and the focal plane is 108 feet above the level of the sea. The light should be visible in clear weather a distance of 17 nautical miles."[123] Whiting also described a thirty-two-foot tall "Beacon Light that was constructed at the same time on Hunting Island. Its purpose was to act as a range light for ships going into St. Helena Sound.[124]

Unfortunately, the new lighthouse did not remain in operation for long. Two years after its completion, the Hunting Island Lighthouse went dark. As with other lights along the coast of the South, the light was taken out of service to prevent use by the Union navy during the War Between the States.

Confederate authorities published a terse notice of the extinguishing of the Hunting Island Lighthouse in several papers in both the North and South, one of which read, "We are requested to state that the Light at Hunting Island has been extinguished for the present. Charleston, April 20, 1861."[125] The expensive lighting apparatus was boxed up and hidden away by Confederate defenders who hoped to put them back into service

once peace was restored. But the valuable lens from Hunting Island did not remain in Confederate hands long.

On the morning of November 11, 1861, a landing party made up of officers from three vessels involved in the attack on Port Royal—the *Umadilla*, the *Pembina* and the *Curlew*—cautiously made its way inland to the town of Beaufort, which it found had been abandoned by the Confederates and most of the inhabitants shortly after the Confederate defenses near the mouth of the harbor had been overrun by the Union navy. The party did find several slaves who had been abandoned and who welcomed the Union naval personnel with open arms. The sailors knew that there was an arsenal of some kind in Beaufort, and they tracked down its location. One of the members of the expedition wrote:

> *We then ordered the negroes to show us the way to the arsenal, and here found property belonging to Uncle Sam which well repaid us for our journey. The entire Fresnel lighting apparatus formerly used on Hunting Island and Martin's Industry was discovered, in excellent condition, except that the massive brass work was somewhat tarnished for want of cleaning. One light is revolving, the other fixed, and both apparatus were imported for the purpose from France at a cost of several thousand dollars. As Commodore Dupont is desirous of immediately laying down the buoys in this great harbor of Port Royal, and rendering it a secure refuge and anchorage for shipping, it would scarcely be possible to over-estimate the value of our discovery. The entire machinery, lamps, burners, clock-work, &c., are now safely on board the* Wabash *and will soon be replaced in their former position.*[126]

Other press reports gave a few more details about the raid. "A letter from Hilton-Head, of the 11th inst., states that the entire Fresnel lighting apparatus formerly used on Hunting Island and Martin's Industry light-house was discovered in excellent condition in the arsenal at Beaufort. They were taken to the steamer *Wabash*, and will be placed in their old position."[127]

One of the early descriptions of what happened to the lighthouse on Hunting Island was penned by the commander of the USS *Pawnee*, one of the U.S. Navy vessels that was engaged in the attack on Port Royal. That vessel made a trip to several locations in the vicinity of Port Royal Sound, including Hunting Island, where its captain and crew

found no signs of Confederate fortifications and the remains of the lighthouse: "The lighthouse had been recently blown up, and all the public property carried away."[128]

Confederate defenders destroyed the first lighthouse on Hunting Island in the early days of the War Between the States. In a report written on April 1, 1862, Flag Officer S.F. Dupont of the Union navy noted, "At St. Helena, the tower was likewise blown up. Immediately after our occupation here, portions of the lens were recovered and sent north."[129]

The nineteenth edition of Edmund Blunt's *American Coast Pilot*, published in 1863, included much of Whiting's 1859 description of the Hunting Island Lighthouse. However, the author did provide some interesting details about the light that had since been blown up. "The light-house on Hunting Island has been destroyed," wrote Blunt. "The frame of the beacon light is standing, but it is washed by the sea at high water and will not long remain in position."[130]

Today, it is possible for visitors to climb to the top of the Hunting Island Lighthouse and look through a telescope to see where the original lighthouse stood. The site of the old light lies well offshore of the northeast end of the island. The remains of many dead trees littering the beach between the current lighthouse and the north end of the island provide vivid evidence of the fact that the same forces of nature that claimed the first Hunting Island Lighthouse are still at work gnawing away at Hunting Island.

Following the war, it was found desirable to reestablish a lighthouse marking the entrance to St. Helena Sound. But much of the northern portion of Hunting Island, where the original lighthouse stood, had eroded into the sea. Lighthouse officials considered a site on the north side of the sound on the southern tip of Edisto Island. But the Federal government owned no land on Edisto Island, unlike Hunting Island, where it was sure some of its property had not been washed into the sea. Thus, a new site was chosen farther down the island and approximately half a mile from the beach.[131]

The new Hunting Island Lighthouse is unique in the annals of South Carolina as it was made of cast-iron plates, the only one of its kind erected in the state. The cast-iron structure consisted of prefabricated sections weighing over one thousand pounds each that were assembled on the site and afterward lined with brick to help weigh the structure down. The reason for choosing this type of construction technique was

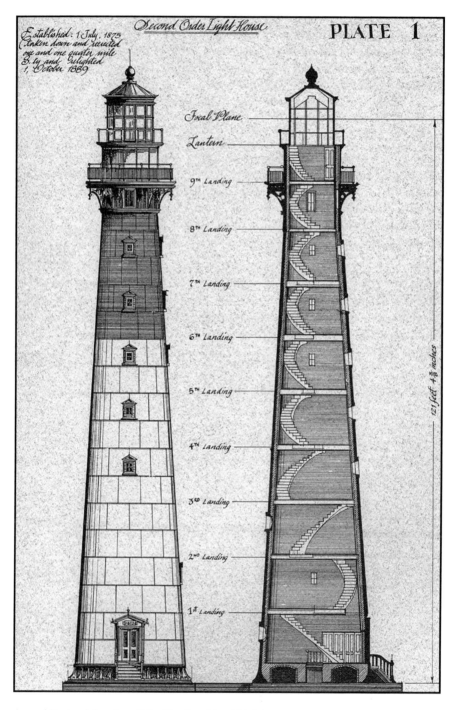

Second Order Light House

PLATE 1

Established: 1 July, 1875
Taken down and Re-erected
one and one quarter mile
S. ly and Re-lighted
1, October 1889

Focal Plane
Lantern
9th Landing
8th Landing
7th Landing
6th Landing
5th Landing
4th Landing
3rd Landing
2nd Landing
1st Landing

121 feet 4⅜ inches

An architectural drawing of the Hunting Island Lighthouse.

explained in the Annual Report of the Light-House Board for 1873: "In view, however, of the continued washing of the shore, it was determined to make the light-house of cast iron, in sections which can be taken down and removed in case of necessity, though it is not believed that such an emergency will arise."[132]

Work on the Hunting Island Lighthouse progressed slowly. Work began in 1873 and took nearly two years to complete. Workers stayed away from the island during the warmer months to avoid illnesses associated with mosquitoes. The second Hunting Island Lighthouse went into operation on July 1, 1875.[133]

The Hunting Island Lighthouse was violently shaken by the Charleston Earthquake on the evening of August 31, 1886. The keeper later reported that the structure "shook so violently that the two assistant keepers in the watch-room at the top could not stand up without holding on to the railing. The second assistant keeper was on the balcony near the top of the tower when the shock occurred. He was thrown from the dome to the balcony railing back and forth. When the shock first commenced, it seemed like a tremor but increased so violently that it seemed as though the bed had been raised from the floor and shaken with great violence."[134]

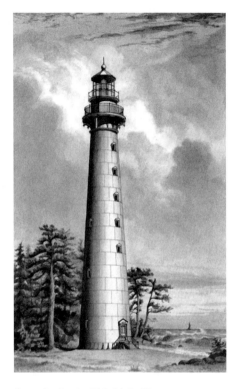

An artist for the U.S. Light House Establishment prepared this drawing of the Hunting Island Lighthouse in 1874. *Courtesy National Archives.*

Though the lighthouse had survived hurricanes and earthquakes, it was unable to escape the steady encroachment of the sea without being moved. It was fortunate that the structure was built in such a mobile fashion, for within ten years after its completion, erosion threatened to claim the Hunting Island Lighthouse. In the annual report for 1887, it was

noted that, on average, Hunting Island lost forty-four feet of beachfront annually. The greatest loss came during the hurricane of August 1881, which eroded sixty-five feet of the sandy beach.[135]

Engineers tried desperately to stabilize the beach in order to save the lighthouse. This included the construction of a "wooden revetment" over 700 feet long on the beach between the lighthouse and the ocean. None of these attempts to hold back the sea were successful. Officials thought the site originally chosen for the second Hunting Island Lighthouse would be safe from incursions of the sea, as the site was half a mile inland. But by 1887, the beach was 133 feet from the lighthouse and only 35 feet from the keeper's quarters.[136]

In 1888, Congress appropriated $51,000 to move the structure farther inland to a site 1.4 miles farther down the island. Work on the site began immediately and included the building of a tram over which the cast-iron pieces could be transported. In addition, work on wooden walls and jetties at the old site was necessary in order to hold the ocean at bay long enough for the lighthouse to be moved to its new site. In the meantime, a temporary beacon "60 feet high from base to focal plane" was put in place on the island to guide mariners into St. Helena Sound.[137]

Workers finished reassembling the lighthouse in September 1889. The annual report for 1890 notes, "Although the working party was suffering from malarial fever, the work of re-erecting the tower was pushed with vigor, and by September 13 it was finished, made ready for lighting and turned over to the keeper."[138]

The light went back into service on October 3, 1889. When it was completed, the light was visible nearly twenty miles out to sea. Workers continued

The Hunting Island Lighthouse in Beaufort, South Carolina. *Courtesy of Barbara Patch.*

putting the finishing touches on some of the other buildings on the station until March 22, 1890.[139] The lighthouse on Hunting Island remained in service until the light was decommissioned on June 16, 1933.[140]

Five years after the Hunting Island Lighthouse was officially decommissioned, the keeper's quarters were accidentally destroyed by fire. This occurred while workers from the Civilian Conservation Corps were stationed on the island, preparing the infrastructure for the Hunting Island State Park.

The Hunting Island Lighthouse continues to be a prominent landmark on the South Carolina coast. It is the only lighthouse in South Carolina open for climbing, and daily visitors make their way up the 167 steps up to the catwalk. For a nominal fee, visitors can tour the grounds of the lighthouse station, where they can see the remains of the keeper's quarters as well as displays set up in various buildings on the complex. The main attraction is the lighthouse, where visitors can get a close look at a unique lighthouse made of brick and iron.

THE CHARLESTON MAIN LIGHTHOUSE/ MORRIS ISLAND LIGHTHOUSE

For more than a dozen years after the Confederate defenders of Charleston were forced by military necessity to destroy the old Charleston Lighthouse, the only lights to shine over Morris Island were the range lights that helped mariners follow the shifting channel entering Charleston Harbor. These aids to navigation served an important purpose but were not of the same magnitude as the former first-order coastal light that could be seen several miles out to sea.

In 1872, Light-House Board officials pointed out the necessity for a lighthouse on Morris Island: "Previous to the war, there was a sea-coast tower and light at this station, and the same reasons that existed for establishing it then, exist still. It will be observed, by reference to the chart, that along the coast, from Cape Romain to the River Saint John, continuous shoals extend out from the main-land to a considerable distance, in many places reaching out as far as six and seven miles. Timely warning of their proximity is necessary for the safety of the lives and cargoes of the large number of vessels that pass them."[141]

On March 3, 1873, Congress appropriated $60,000 for the "rebuilding of a first-order seacoast light on Morris Island destroyed during the war." Site selection and work on the foundation began that year, "as soon as the sickly season is over."[142]

Major Peter Hains of the U.S. Army Corps of Engineers was the engineer who designed the structure. In addition to being a well-

respected designer of lighthouses, Hains was renowned as the soldier who fired the first artillery shot for the Union army during the Battle of First Manassas in 1861.[143]

In June 1874, Congress appropriated an additional $60,000 toward construction of this lighthouse. Work on the foundation continued in earnest. The Light-House Board's annual report for 1874 described the extent of the work:

> As the tower will necessarily be a heavy one, it was decided to form a pile and grillage foundation. The piles are to be driven 3 feet apart from center to center, then cut off below the level of the water. On top of the piles a grillage composed of two thicknesses of 12-inch square timbers are to be laid at right angles to each other. The space between the grillage timbers, and for three feet below, is to be filled in with concrete and to extend 2 feet outside the piles. The two outer rows of piles are to be driven 50 feet, the interior ones to a depth of from 25 to 35 feet if sufficient bearing capacity is found. The base of the tower below the surface of the ground will be concrete or rubble masonry, on which will rest the brick shaft 150 feet in height.[144]

The metalwork for the tower was completed in the fall of 1875. Earlier that year, Congress had appropriated $30,000 more toward completion of the project.

Work on the lighthouse and keeper's quarters was completed in 1876. The project's final cost was $149,993.50. The Light-House Board's 1876 report described the light as follows: "The illuminating apparatus, a first-order lens, fixed white, with an arc of 270° and a catadioptic reflector of 90°, has been set up. The oil and work rooms have been built, and the tower is ready for lighting."[145]

The Charleston Main Light, as it was officially designated, went into operation on October 1, 1876. The lighthouse stood 158 feet tall. The structure was not painted until 1878, and it was repainted in 1880. Four years later, in 1884, the entire complex was again repainted, and the lighting apparatus inside the lighthouse was modified so it could use mineral oil instead of lard oil.[146]

Several fierce hurricanes struck the Charleston area in the final two decades of the nineteenth century. Perhaps the most memorable one for the keepers of the lighthouse on Morris Island was the one that

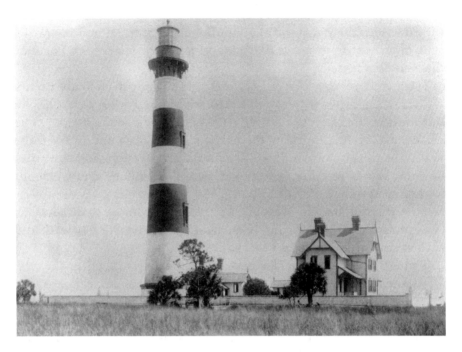

The Morris Island Lighthouse, circa 1885. *Photo courtesy National Archives.*

struck Charleston on August 25, 1885. The brick wall surrounding the station was partially destroyed, and the plank walkway connecting the lights with the keeper's quarters was washed away. The most important loss was the Morris Island Range Beacons, which were destroyed in the storm. The Annual Report of the Light-House Board for 1886 notes, "The range was re-established on the 28th by a light shown from a temporary beacon. A new wooden skeleton structure 40 feet high, with inclosed [*sic*] service-room and lantern, was built, and a light was shown from it in November."[147]

Another memorable natural calamity that struck the city during this period was the Charleston Earthquake. When the great earthquake struck Charleston on August 31, 1886, the Morris Island light keeper was standing in the doorway of the lighthouse, where he rode out the first two shocks. Thinking that the worst was over, he ascended the tower to check on the lantern and was in the lantern room when the third shock occurred. Though he could hardly stand, he did notice

the effects of the quake on the lighting apparatus: "The lens swung from southeast to northwest, back and forward, about three or four times in a second."[148]

Several more shocks were felt that evening, with at least twenty shocks being experienced at the Morris Island Lighthouse. Despite the rocking, the tower survived with only moderate damage. "The earthquake of August threw the lens out of position and cracked the tower extensively in two places," reported the keeper, "but not so as to endanger its stability. The upper and most serious crack extends somewhat spirally almost through a full circumference of the tower, but the sides of the crack are in very close apposition, and there has been no lateral displacement. The lens was immediately replaced, and broken parts were repaired without delay."[149]

Though not as spectacular as an earthquake or a hurricane, the most potent threat to the light station was beach erosion. In June 1892, an unusually high spring tide washed away enough beach to make it necessary to remove the south and north range lights on Morris Island. As improvements to the Swash Channel leading into Charleston Harbor were underway, these range beacons were replaced with temporary markers. The beacons were discontinued in 1899 when work on the channel was finished.

Thanks to the threat of an incursion by the Spanish fleet during the Spanish-American War, the Charleston Main Lighthouse was equipped with a telephone and direct line into the city in 1898. The Annual Report of the Light-House Board for 1899 notes, "A spar, international flags, marine glasses, and signal books were supplied to the keeper."[150]

As time passed and aids to navigation improved, the importance of the lighthouse on Morris Island diminished. In 1938, the U.S. Coast Guard automated the lighthouse and removed the keepers from the station. At the same time, they removed the first-order Fresnel lens, replacing it with a fourth-order acetylene light of six thousand candlepower.[151]

Erosion on Morris Island worsened, and by the late 1950s, the Charleston Main Light was in danger of being toppled into the sea. In 1960, a new lighthouse was begun on the north side of Charleston Harbor that would replace the old lighthouse. The Charleston Main Lighthouse was officially deactivated on June 15, 1962.[152] The beach has continued to erode to the point that the lighthouse, which

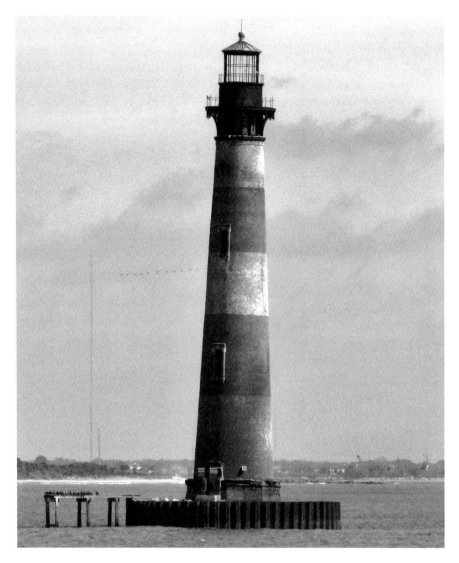

The Morris Island Lighthouse near Folly Beach, South Carolina. *Courtesy of Larry Myhre.*

originally stood nearly 1,500 feet from the sea, is now over 1,500 feet from the shore. But the old lighthouse refused to fall, giving ample testimony to the skill and ingenuity of the workers who built its extensive foundation in the 1870s. At one point, the U.S. Coast Guard considered tearing down the structure before it fell and became a

menace to navigation but, yielding to popular opinion, decided not to follow through with this effort.

Today, the Charleston Main Lighthouse/Morris Island Lighthouse is owned by Save the Light Inc., a nonprofit organization dedicated to preserving this important historic landmark at the entrance to Charleston Harbor.

LIGHTHOUSES ON HILTON HEAD ISLAND

The Hilton Head Lighthouse rises above Hilton Head Island and, with the help of other range lights erected in the area, once guided mariners to the entrance of Port Royal Sound and Calibogue Sound. The old rear range light is the only one of these structures to survive and has the distinction of being the only steel-skeleton lighthouse built along the South Carolina coast.

A set of range lights was set up on Hilton Head prior to the War Between the States, but like other stations along the southern coast, the lights were taken out of commission early in the war to keep them from being of use to the Union navy. After Federal forces captured the strategically important area around Port Royal, they wasted little time in reestablishing lights to help their vessels safely into port.

After the war, the Lighthouse Board upgraded lights on Hilton Head in November 1865. Lighthouse Inspector F.B. Ellison reported, "A Range Beacon Light has been substituted for the Fourth Order Lens Light, formerly shown at the Front Beacon on Hilton Head Island, lighting the southern channel into Port Royal. These Beacons will now show with equal brilliancy, and the Back Beacon Light will appear over the Front Light when they are in range."[153]

Congress appropriated $40,000 for the erection of a new set of range lights on Hilton Head in 1876. These replaced the set of lights that had been erected on the island shortly after the end of the war. Lengthy

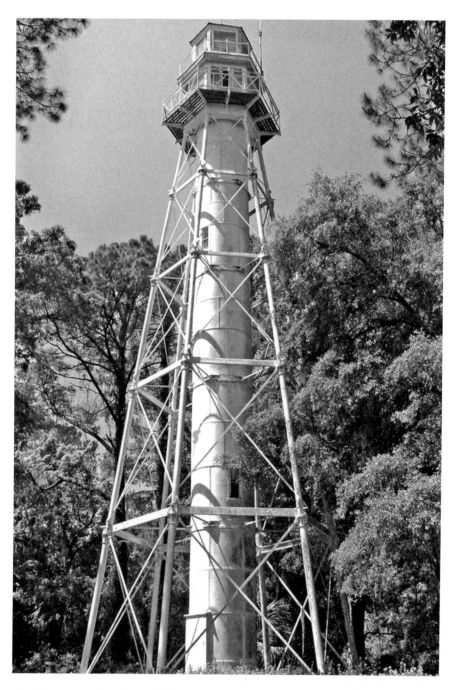

The Hilton Head Rear Range Light still stands guard over Hilton Head Island.

negotiations followed over price for the land upon which the light station was to be built, and on September 4, 1877, the U.S. government purchased the land for the lighthouse from Cesar Parmelee.[154]

Captain W.A. Jones, engineer for the Sixth Lighthouse District at Charleston, solicited bids for construction of the steel tower and the accompanying structures in the summer of 1878. He noted, "The structures comprise two wooden frame dwellings and one iron frame tower 87 feet high."[155]

Construction began in 1879. Work proceeded rapidly, and the Rear Range lighthouse was finished in 1880. The Hilton Head Rear Range Lighthouse went into operation the same year.[156]

The 1879 report of the Light-House Board described the new lighthouse in the following terms: "The tower is a skeleton structure made up of five series of iron columns, braced and tied together by means of beams and tie-bars, together forming the outline of a regular hexagonal pyramid with a central cylinder inclosing [sic] the axis of the pyramid. The first series of columns are fitted into foundation discs which rest on a concrete foundation 6 feet thick and are bolted down to the same. On the top is built an inclosed [sic] watch-room and lantern, which will be fitted with a reflector light." The tower stood eighty-nine feet tall.[157]

The Front Range Light consisted of a light affixed to the roof of a wooden house on long legs or stilts built one mile in front of the Rear Range Light. Due to the frequent shifting of the channel, the building was converted into a more mobile structure in 1884 so that it could be more conveniently repositioned to mark the meandering channel.[158]

The contract for construction of the structures at this light station stipulated that work be completed by June 1, 1879. However, as that time rolled around, work had not begun on the keepers' dwellings or the Front Range Light. Therefore, a new contract was let for these structures, with the deadline extended until May 1, 1880.[159]

Work on the Hilton Head Range Lights and accompanying structures was completed by June 1880. The Light-House Board held off on lighting the beacons on Hilton Head Island until the nearby Parris Island Range Lights were also operational.[160]

Parris Island was not the first choice for location of these range lights. A set of range lights had originally been designated for Bay Point, but because of various legal problems, this proved to be impossible. So on June 20, 1878, nearby Parris Island was chosen for a set of range lights

instead of Bay Point. Title for the land was secured in 1879, and work on the light began in the fall of 1880.[161]

Once the legal matters were taken care of, work proceeded at a rapid pace, and the Parris Island Range Lights were completed in the summer of 1881. The annual report of the Light-house Board for 1881 gave the following description of the site: "Two lights were established here to be used, in connection with those on Hilton Head, for entering Port Royal Harbor. The rear structure is a triangular iron pyramid 120 feet high, the burner of which will be hoisted into place by a mechanism made for that purpose. The front light will be shown from a wooden tower about 45 feet high."[162]

Once work on the Parris Island Range Lights was completed, everything was in place to illuminate the beacons that would guide mariners into Port Royal Sound. The lighthouse on Hilton Head and accompanying range lights went into operation on August 1, 1881.[163]

The first few years of the Hilton Head Lighthouse were tumultuous ones, thanks to numerous hurricanes and a massive earthquake. The keeper was in his quarters when the first shock of the Charleston Earthquake struck in the summer of 1886. By the time the second shocks arrived, the keeper was in the lighthouse, where he rode out the shaking in the entrance to the lantern room. He later noted that "the whole tower shook and heaved like a small boat in a heavy sea." But the light was not damaged significantly.[164]

Interestingly, the assistant keeper believed the commotion at Hilton Head during the Charleston Earthquake was supernatural in origin. He reported, "His assistant and his wife say that they did not notice it much. They thought it was the ghost of a former assistant who lies buried near the house and that he was giving them a shaking up."[165]

The keeper of the lights on Parris Island had his own adventures during the earthquake. While relaxing in his home and catching up on some reading, he noticed that the cows outside were making an unusual amount of noise. This was shortly followed by a rumbling, thunder-like noise accompanied by the initial shocks of the earthquake. The keeper ran outside to check on his light, thinking that the 120-foot tower was about to fall. But when the shaking stopped, there was no apparent damage to the lights on Parris Island.[166]

A constantly shifting channel combined with erosion of the island made moving the Front Range Light on Hilton Head a regular event.

Even after the light was moved onto a mobile structure in 1884, there were problems with the arrangement. By 1887, lighthouse officials were asking Congress for an appropriation to purchase land adjacent to the site in order to cut down trees and shift the range light adequately.

The Light-House Board pointed out the critical nature of the problems facing the Hilton Head lights in 1890: "In the annual report for 1887, and yearly since that date, it was reported that the front beacon, in following the movement of the channel, through which it is intended to guide, to the southward, had reached the southwestern boundary of the reservation, and an appropriation of $1,000 for the purchase and clearing of 50 acres of adjacent land was recommended. This channel has now passed so far beyond the range that very soon it will be necessary to change the site of the lights to avoid leading vessels into shoal water and to their destruction."[167]

An appropriation for $1,000 soon passed. On February 27, 1891, additional land was purchased from Linda Reddick, thus enlarging the bounds of the Hilton Head Lighthouse.

In January 1897, the front range light was shifted significantly as the channel continued migrating south. This action was no minor repositioning but instead was a major undertaking requiring much effort to accomplish. The annual report for the Light-House Board for 1897 explained, "A new foundation was prepared for it and 10 acres of dense woods cut down to clear the range of obstructions."[168]

The Hilton Head Range Lights were discontinued in 1932. Though the front range light was subsequently taken away, the rear range lighthouse remained. A decade later, the steel-skeleton structure was utilized as a lookout post during World War II.

In 1985, the Hilton Head Lighthouse was acquired by the Greenwood Development Corporation, which repaired much of the damage resulting from many years of neglect. The lighthouse is now part of the Palmetto Dunes Oceanfront Resort, where it rests in the woods between the fifth and fifteenth holes of its world-famous golf course. Though it is located on private property and not visible from the William Hilton Parkway, the lighthouse has survived into the twenty-first century as an important part of the long and unique history of Hilton Head Island.

LIGHTHOUSES ON DAUFUSKIE ISLAND

Daufuskie Island is the southernmost inhabited island along the coast of South Carolina. Lying on the north side of the Savannah River, the island is steeped with history and lore dating back hundreds of years, long before the founding of Carolina. No one knows exactly when the first aid to navigation was established on Daufuskie Island. Legends maintain that an aid to navigation was in use at Bloody Point long before the U.S. Light-House Board constructed lights there. A local resident is said to have burned a candle in the window of his house, which mariners would use as a landmark on their journeys to and from Savannah.

For many years, people traveling along this stretch of coast relied solely on the lighthouse on Tybee Island, Georgia. This beacon was seen by those navigating into both Savannah and Charleston from the south. The lighthouse on Tybee was especially useful for those traveling into Calibogue Sound and Port Royal Sound. Lawrence Furlong pointed out the importance of this Georgia lighthouse to those headed into South Carolina: "Some, when bound to Port Royal, reckon it best to make land about Tybee, because the Light-House, which is a large wooden tower without any light kept in it, makes that part of the coast distinguishable from any other part. Tybee Inlet is the entrance of Savannah River. Ships which draw 14 or 15 feet water may go in at Tybee and proceed through land to Beaufort; vessels of 8 or 9 feet water may go through land to Charleston. From Charleston,

vessels drawing 7 or 8 feet water may go through land to the River Midway in Georgia."[169]

Two official light stations once cast their beam over Daufuskie. On the southern end of the island was the Bloody Point Range Light, whose primary purpose was to help guide ships into and out of the Savannah River. On the northern end of Daufuskie Island at Haig Point, where the waters of Calibogue Sound and the Cooper River meet, another set of range lights operated, the surviving structure looking more like a cozy beach cottage than an aid to navigation. Yet mariners have been utilizing this landmark for nearly a century and a half.

Realizing the importance of this local trade between Savannah, Beaufort and Charleston, the U.S. Light-House Board embarked upon an effort during the post–Civil War years to establish aids to navigation across Calibogue Sound between Hilton Head, South Carolina, and Tybee Island, Georgia. To accomplish this, it was decided to establish the aforementioned range lights on Daufuskie Island, one at the northern end of the island at Haig Point and another set on the southern tip of the island at Bloody Point.

Work on the first set of lights on Daufuskie Island began at Haig Point in 1872. Congress appropriated money for the lighthouse in 1871 and in the spring of the following year purchased from members of the William Pope family five acres of land on the northern tip of Daufuskie Island. Soon thereafter, workers began construction of the range lights at Haig Point. Work was finished on both beacons by October 1873.[170]

The lighthouse incorporated into the keeper's dwelling served as the rear range light. The lighting apparatus was housed atop the dwelling and originally held a fifth-order Fresnel lens and kerosene lamp. The house itself was a wooden, two-story Victorian structure, painted white. The front range beacon was also made of wood, but instead of being built atop a house, it was mounted on a moveable frame. This allowed for the structure to be moved as the channel shifted. A locomotive headlight was utilized as the lighting apparatus.[171]

The front tower stood just fifteen feet tall. Approximately 750 yards to the north of this structure was the rear light. Lighthouse officials noted that the lighthouse atop the keeper's dwelling at Haig Point carried a light "with a focal plane of 49 feet above its base."[172]

Soon after the Haig Point Lighthouse went into operation, it was noticed that there was a problem with plaster falling from the ceiling

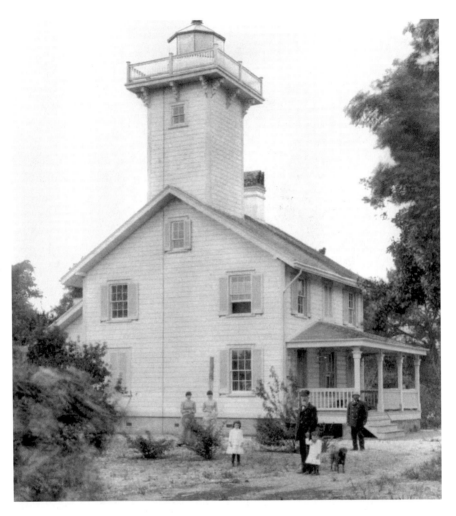

This photo of the Haig Point Rear Range Light on Daufuskie Island was taken in 1885.
Photo courtesy U.S. Coast Guard Historian's Office.

of the keeper's house. This problem was exacerbated by the Charleston Earthquake, which shook the building violently and caused wide cracks to appear in the walls. Finally, in 1888, after a thorough investigation of the problem, the official report noted, "Great difficulty was always experienced in keeping the plastering of the dwelling in good condition because the tower for the rear light, with a focal plane of 49 feet above the base, is a part of the dwelling and communicates its vibrations to the

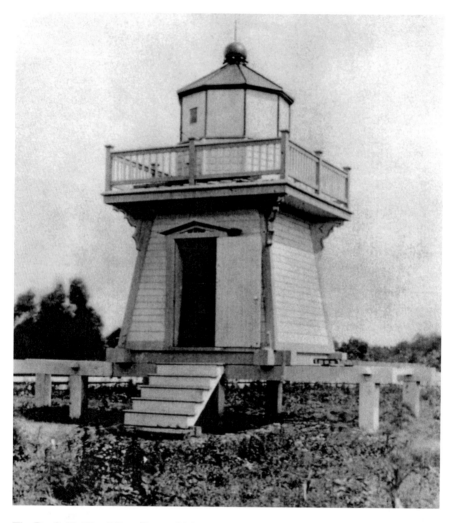

The Daufuskie Island Front Range Light as it appeared on June 11, 1885. *Photo courtesy U.S. Coast Guard Historian's Office.*

room below. All the plastering of the tower and the apartments in close contact with it was removed and replaced with grooved and tongued ceiling boards, and all of the leaks in the lantern and roof were stopped."[173] This apparently solved the problem, as there were no subsequent reports of problems in future reports.

The lighthouses on Daufuskie Island were battered by several severe hurricanes in the first few years of their existence. In August 1881, the

lights at Haig Point sustained much damage from a hurricane. In his annual report, the light keeper noted, "This station was so much damaged by the hurricane of August 1881 as to need extensive repairs. A plank walk, a boathouse, and a wharf, all on piles, were built. The dwelling, beacons, and fences repaired, and all the trees and bushes were cut away between the lights."[174]

Without question, the most ferocious hurricane to affect Daufuskie Island was the Sea Island Hurricane of 1893—a destructive storm that claimed more than two thousand lives in the Lowcountry of South Carolina and Georgia. The winds from this ferocious storm battered but did not destroy the lighthouse at Haig Point. Storm-driven waters of Calibogue Sound ate away thirty feet of the high bluff on the northeast side of the island.[175]

The lights on the northern end of Daufuskie Island became obsolete by the 1930s, or so the U.S. Lighthouse Bureau believed. Therefore, in

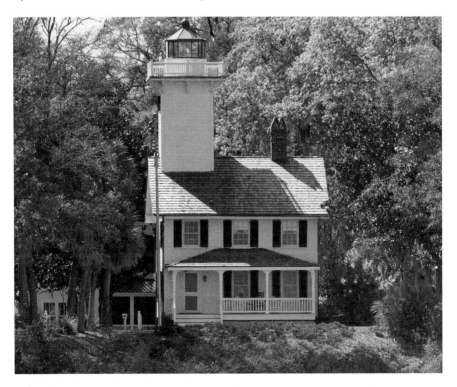

The Haig Point Lighthouse on Daufuskie Island. *Courtesy of Barbara Patch.*

July 1924, the lights were officially deactivated.[176] In the years following their deactivation, the Haig Point Range Lights were used for a variety of purposes, including as a hunting camp. The structures soon began to deteriorate after being left to the mercy of the elements. The rear range light continued to deteriorate until it was purchased and partially restored in the 1960s by George Bostwick. In 1984, International Paper Realty Corporation purchased the site and, in consultation with architect Bill Phillips, vigorously set about working to restore the old lighthouse. Work was completed in 1986, and the light was reactivated later that October. This beacon, a solar-powered light, is recognized by the U.S. Coast Guard as an official "private" navigational aid.[177]

Daufuskie's other set of range lights stood on the southernmost end of the island at Bloody Point. From Bloody Point, one can look south across the water into Georgia and see such prominent landmarks as the historic Tybee Island Lighthouse and Fort Pulaski. In conjunction with the lighthouse on Tybee Island, the Bloody Point Lighthouse guided mariners into the entrance of Georgia's most important commercial river for nearly forty years.

The U.S. Light-House Board decided to establish a regular set of range lights marking the northern limits of the entrance to the mouth of the Savannah River in 1881. As a part of this system, two lights were built on Daufuskie Island, a front and rear range light. South Carolinian James LaCosta was given the contract for the Bloody Point Front Range Light. He constructed a wooden, Victorian-style house, on the second floor of which he placed the lighting apparatus. The red beam from this light shone through a large dormer window facing the sea.[178]

The contract for the construction of the Bloody Point Rear Range Light was given to John Doyle of Ohio. He constructed a metal tower 81 feet tall and situated 4,350 feet inland from the front range light. Atop this structure was affixed a headlight from a locomotive, which emitted a red light visible, on clear nights, twelve miles out to sea. During the daytime, the lamp was taken down by the keeper and stored in a small brick building that stood adjacent to the tower. Both lights were operational by the spring of 1883.[179]

Doyle apparently liked the area so much that he decided to stay on after he completed his construction project. He took the job as light keeper at Bloody Point, a position he held for seven years. In 1890, he was replaced by Robert Sisson, who held the post nearly eighteen years

View from Bloody Point looking across the mouth of the Savannah River into Georgia.

before being replaced by his son, Charles Sisson. The latter served until the summer of 1910, at which point he was temporarily replaced by his father. A few months later, Gustav Ohlman took over. Ohlman served until the light station was decommissioned.[180]

A detailed description of the light was included in the first edition of the U.S. Coast and Geodetic Survey's *Atlantic Local Coast Pilot*, released in 1885. When giving directions for entering Savannah River, the

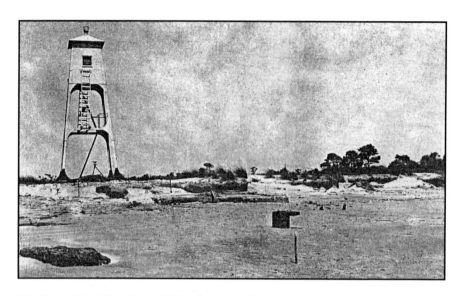

The Bloody Point Front Range Light, circa 1900. *Photo courtesy National Archives.*

compilers included the following particulars concerning the new lights on Bloody Point:

> *Daufuskie Island is nearly five miles in length and heavily wooded. Near its southern extremity, called Bloody Point, is situated the Bloody Point Range Beacons. This range intersects the Tybee range and serves to guide vessels into the Roadstead after crossing the bar. The front light is exhibited from a window in the roof of the keeper's dwelling at an elevation of twenty-three feet above the level of the sea. It is a fixed red reflector light and is visible at a distance of nine and three-fourths miles. The rear beacon is a triangular skeleton tower eighty-one feet in height, situated three-fourths of a mile NW ½ N from the front beacon. From it is shown, at an elevation of eighty-five feet above the level of the sea, a fixed red light, visible in clear weather at a distance of fifteen miles. From this light, Tybee light-house bears S by E ¾ E, distant seven and three-eighths miles. Both these beacons show their greatest brilliancy only within half a point of the range.* [181]

The Bloody Point Range Lights functioned well at first, but as with most other lighthouses along the southern coast of South Carolina, erosion

threatened to wash the structure into the sea. In the annual report of the Light-House Board for 1883, it was noted that the boathouse and other structures had been moved inland. The report also pointed out, "The sea is encroaching seriously on the site, and it is probable that all the structures at the front beacon will require removal in the near future."[182]

Three years after taking over as light keeper at Bloody Point, Robert Sisson survived the arrival of the Great Sea Island Hurricane of 1893. Daufuskie was in the destructive right front quadrant of the storm, and Bloody Point took the full fury of this hurricane. Water ran waist deep through the house as the storm surge inundated Bloody Point. Fortunately, Sisson and his family members survived, but Sisson suffered much damage to his own personal property and livestock. He later calculated that he had lost $74.68 in personal goods and an additional $13.80 for "46 head of fine chickens."[183]

The encroaching waters of the sea threatened to claim the Bloody Point Front Range Light. Congress appropriated funds to move the range light in March 1899. Work began immediately, and the structure was moved over four thousand feet inland and placed next to the Rear Range Light. From this point on, the Bloody Point Lighthouse ceased operations as a lighthouse and was utilized exclusively as the keeper's quarters. A light was relocated from nearby Venus Point on the Savannah River and erected near the beach to serve as a front range light. Work was completed at Bloody Point by December 1899.[184]

The lights on Bloody Point became less important as the channel into Savannah shifted. A notice to mariners mentioned that the lights would be permanently discontinued in November 1912: "There will be a change in the range lights in Tybee Roads, Savannah River approach, after tomorrow. The present Bloody Point Range Lights are to be permanently discontinued and new lights to be established to work the axis of dredge channel through Tybee Roads."[185]

With the advent of modern aids to navigation, the need for a set of range lights marking the northern approaches to Savannah River decreased. The light station at Bloody Point was discontinued in 1921. The property was sold at public auction in January 1922, with Francis Keenan purchasing it for $525.15.[186]

The Bloody Point Range Lights and their ancillary structures have had an interesting history since being decommissioned and have been utilized for a variety of purposes. The person most often associated with Bloody

Point was Papy Burn, who served as assistant keeper to Ohlman. After the light was taken out of service, Burn eventually obtained ownership of the structure and made it his home for over forty years. During that time, he operated the Silver Dew Winery on the grounds of the property.[187]

The property has changed hands several times since Burn sold it in 1966. At one point, it was utilized as a pro shop for the Bloody Point Golf Club. In 1999, the former lighthouse was acquired by private individuals, who currently utilize it as a private residence and who have expended much effort restoring the old Bloody Point Lighthouse. Though not open to the public, the former lighthouse and several associated brick structures are visible from a wayside exhibit built adjacent to the sandy road.

THE SULLIVAN'S ISLAND LIGHTHOUSE

B y the mid-1950s, those interested in safe navigation into and out of Charleston Harbor realized it was clearly only a matter of time before the ocean claimed the Charleston Main Lighthouse on Morris Island. Should the tower topple into the sea, it would leave one of the country's most important ports without a lighthouse. The challenge presented by the impending demise of the lighthouse on Morris Island offered U.S. Coast Guard officials an opportunity to build a unique and innovative structure unlike any seen before in the Palmetto State.

The site for the new lighthouse was on the north side of the entrance to Charleston Harbor, near the old lifesaving station on Sullivan's Island. This was not the first navigational aid to be built upon this island. During the colonial era, an unmanned beacon was built on the island to serve as a landmark for mariners heading into Charleston, but this was not an official aid to navigation. Later, in 1848, beacons were officially established near Fort Moultrie to guide ships into the channel entrance to Charleston Harbor. These were destroyed during the War Between the States.

Following the war, another set of range lights was erected on Sullivan's Island. The first set was built in 1872. Later, in 1888, another light was added. Though originally known as the Sullivan's Island Range Lights, this station was renamed the South Channel Range Lights in

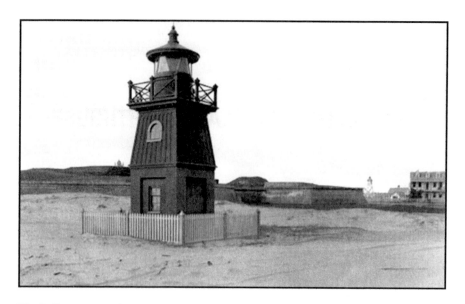

The Sullivan's Island Range Lights are visible in this 1896 photo. *Photo courtesy U.S. Coast Guard Historian's Office.*

the spring of 1899. The light station on Sullivan's Island was officially discontinued in 1933.[188]

Construction began on the current lighthouse in 1960. The structure is unique among the lighthouses in South Carolina in that it is triangular (rather than circular) in shape. The panels are made of aluminum alloy affixed to steel girders secured to a concrete foundation. The structure is 163 feet tall and was originally painted orange and white.[189]

Many of the local inhabitants were not pleased with the unorthodox coloring of the lighthouse, so they asked the U.S. Coast Guard to change it to a more traditional color scheme. The coast guard granted the request and agreed to change the color pattern, first to red and white and, later, to black and white.

The Sullivan's Island Lighthouse contains several innovations not normally associated with a lighthouse. Jack Graham, the U.S. Coast Guard architect who designed the structure, equipped the new lighthouse with many modern conveniences, including offices and air conditioning. It also was reputed to be the only lighthouse in the United States equipped with an elevator.[190]

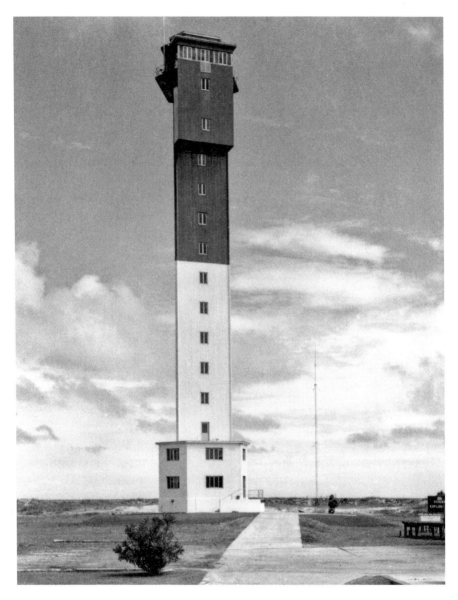

The Sullivan's Island Lighthouse is unique for many reasons, the most noticeable being its triangular shape. *Photo courtesy U.S. Coast Guard Historian's Office.*

This aerial photo shows the Sullivan's Island Lighthouse shortly after it was constructed. *Photo courtesy U.S. Coast Guard Historian's Office.*

When the new lighthouse was activated on June 15, 1962, officials from the headquarters of the Seventh Coast Guard District proclaimed it "one of the most powerful lighthouses in the Western Hemisphere." They went on to note, "The new Charleston light has 28 million candlepower and is visible for 20 miles. There are six separate lights mounted on an aluminum base, which weighs 1,800 pounds."[191] Although it was clearly visible many miles out to sea, the beacon's powerful beam posed a potential hazard to those tasked with serving the light. The powerful light also drew some complaints from neighbors. To alleviate these problems, U.S. Coast Guard officials decided in 1966 to dramatically reduce the light's output by cutting it back to 1.7 million candlepower. Even with its power drastically cut, the light can still be seen twenty-six miles out to sea.[192]

The Sullivan's Island Lighthouse was automated in 1982, and this unique lighthouse continues to guide mariners into Charleston Harbor. Ownership of the Sullivan's Island Lighthouse was transferred from

the U.S. Coast Guard to the National Park Service during a ceremony on the grounds of the lighthouse on November 9, 2008. Today, the lighthouse and the historic structures that surround it are administered as part of the Fort Sumter National Monument.

FORT WINYAH, 1858

The following document is a transcription of a notice for proposals for a lighthouse at Fort Winyah, Georgetown, South Carolina. The specifications for the proposed structure were prepared by W.H.C. Whiting, who, at the time the document was written in 1858, was serving as the engineer for the Sixth Light House District. This notice was printed in the *Pee Dee Times* on February 24, 1858. Unfortunately, the drawings alluded to in the notice were not published in the newspaper and have yet to be uncovered. Perhaps the drawings or even a photograph of the structure will turn up and help to shed more light on this nearly forgotten lighthouse.

Notice
Engineer's Office 6th L.H. District
Fernandina, Fla., Jan. 28th, 1858

Proposals will be received at this office until 10 o'clock A.M. of the 28th proximo for building a Light House upon the site of old "Fort Winyah," near Georgetown, S.C., according to specifications herewith advertised.

A plan of the building has been forwarded to the collector at Georgetown with a request that he will exhibit it to all persons desiring to make proposals.

Appendix I

The engineer in charge reserves the right to reject any or all of the bids.

Wm. H.C. WHITING
Engineer, 6th L.H. District

Specifications for a Light House at "Fort Winyah" near Georgetown, S.C.

Foundation—There will be under the sills of the piazza twenty brick pillars, one brick and a half square, two feet above ground, and under the sills of the main building there must be twenty-four pillars, the same in size and height as those under the piazza; their places are expressed in the drawing by a dot in black ink. If in examining the site to the building it should be necessary to drive a pilling under each pillar, it must be enclosed in the estimate.

Frame—The scantling for the frame must be of good merchantably [sic] quality, sills 6 x 8, corner post 6 x 8, lower post 3 x 8, tie beams 3 x 8, lantern post 6 x 6, door and window post 4 x 7, studs 3 x 4, piazza post 6 x 6, braces 4 x 6, bearers in piazza 6 x 6, joist in piazza 3 x 6, lantern floor post 3 x 4, and the two pieces spiked on to the lantern post 4 x 4. Pieces spiked to the rafters to make the piazza roof are cut out of 1½ inch plank.

Flooring—To be of quartered boards tongued and grooved and 1¼ thick, clear lumber.

Weather-Boarding—Of best quality not to show more than 4½ inches to the weather and lap not less than 1¼ inch.

Roof—Lathed with strips 6 inches wide, 1¼ thick and 4 inches apart, and shingled of good, well drawn black Cypress, 22 long, not less than 4 wide and 5/8 inches thick at the butt and courses to show no more than 5½ to the weather.

Windows—Are 15 lights 10 by 12 glass, the glass must be strong and thick and of fair quality, jamb casings 1½ thick, and facings 6 inches wide, and on the outside thick enough to receive the weatherboarding without back mouldings, sills not less than 2 thick Venetian blinds,

stationary slate, to all the windows, and in the roof and sky lights as seen in the drawing.

Doors—All the doors 2 by 10 wide, 6 by 10 high, except the door leading to the stairs, which is 6 by 8, and 2 by 8, all 1½ thick.

Mantles—Four plain mantles to suit the fire places. Venetian door, to be maid [sic] to suit the drawing.

Chimneys—There will be two chimneys as seen in the drawing, also at the fire place 6 by 3, and where the flues go outside the roof good hard brick must be used.

Plastering—All the rooms on the lower floor will have two good coats of plastering, first a rough coat floated, and then covered with a thin coat.

Painting—The roof will be well painted with Blakes' patent roof paint, and all the other woodwork covered with three coats of pure white lead and oil.

Hardware—All the doors will have the best quality of cottage locks, hinges, cast iron 4 by 4, hooks, staples, bolts, sash locks, and every fastening necessary to make a finish to the work, will be expected to be included in the estimate. The estimated at the present to be made only as high as the lantern floor. If it should be decided to have a lantern of wood, there will be furnished from this office a complete working drawing of the same. In the garret, the floor will be laid out no other finish will be made, no furring, lathing or plastering.

Wash Board—To all the rooms 9 wide.

Architraves—Inside architraves will be required to all the doors and windows 5 wide, and not less than 1 thick.

Ceiling—All the piazza over head will be ceiled with ¾ ceiling.

CIVIL WAR LIGHTHOUSE REPORT

In the early days of the War Between the States, the Committee on Commerce and Manufactures was charged by the South Carolina General Assembly to examine the operations of the lighthouses, lightships and all other activities related to the lighthouses. This was done for a number of reasons, the main one being to learn the expenses involved in the administration of the aids to navigation along the coastline of the Palmetto State—expenses for which the recently seceded state would now be responsible. Representative Richard Yeadon, chairman of the committee, submitted the following report to the general assembly. This document is part of the collections of the South Carolina Department of Archives and History.

> *The Committee on Commerce & Manufactures, to whom was referred the Resolution instructing them, among other things, "to inquire + report the number of Light Houses, Light Boats, Beacons + Buoys on the coast + in the harbours of this State, and the annual expenses of maintaining the same," so far as the said Resolution relates to Light Houses, Light Boats, Beacons and Buoys, respectfully report that they have discharged the duty assigned them, so far as was practicable, and they find that the Light House establishment on the coast + in the harbours of South Carolina consists of three Light Houses, six Beacons, and one Light Vessel; that the localities of the Light Houses + Beacons are as follows,*

viz. Georgetown, Cape Romain, Bulls Bay, Charleston, Morris Island, Sullivan's Island, Fort Sumter, Castle Pinckney + St. Helena Bar, and the Light Vessel is on or near Rattlesnake Shoal; and that there are various Buoys, stationed at proper points, in the several harbors of the State. The Committee further report that the annual expense of maintaining the Light House + Buoy establishment, on the coast + in the harbours of the State, is Twenty-Three Thousand Two Hundred + Twenty Two ($23,222) Dollars, as will appear by a Schedule hereto annexed.

Respectfully Submitted,
Richard Yeadon
Chairman

Schedule

Statement of the expenses of the Light House establishment in the District of Charleston for the fiscal year ending July 30, 1860

14 Light House Keepers + Assistants	*$5266.00*
1 Light Vessel	*$700.00*
4 Buoy Tenders + Crews for the 6th Dist. extending from New Inlet, NC to Smyrna FLA	*$2500.00*
Rations for Light Vessels	*$4995.00*
Wages of Seamen on Lt. Vessels	*$1950.00*
Repairs of Lt. Vessel	*$2067.00*
Fuel of Lt. Vessel	*$350.00*
Supplies for Lt. Houses including oil, wick + polishing materials furnished by Govt	*$5399.00*
	$23,222.00

GEORGETOWN LIGHTHOUSE, 1810

The following document, published in the spring of 1810, is a solicitation for bids to construct the Georgetown Lighthouse. There are several interesting details about the structure revealed in this document. The notice is copied from the June 26, 1810 edition of the *City Gazette*, a newspaper published in Charleston.

> *TREASURY DEPARTMENT*
> *April 13th, 1810*
> *PROPOSALS*
> *Will be received at the Office of the Secretary of the Treasury, for rebuilding a Light House on North Island, at the Entrance of Georgetown Harbour, in the State of South Carolina, of the following materials, dimensions and descriptions—*
>
> *The Foundation to be dug seven feet deep and to be mild masonry, either red bricks or stone. The diameter to be twenty-seven feet, the form either circular or octagon. The Tower or Pyramid to be either circular or octagon, 75 feet high above the surface of the ground, 26 feet external diameter at the surface of the ground, and 12 feet external diameter at the top or floor of the Lanthorn. The Walls all of brick or stone, to be graduated as followeth, viz. the first sixteen feet from the base to be 5 feet 6 inches thick, the next fourteen feet is 4 feet 6 inches thick, the next twelve feet, 3 feet six inches think, the next eleven feet, 3 feet thick, the*

next ten feet, 2 feet 6 inches thick, and the next nine feet, 2 feet thick. The two upper courses to be marble or free stone going across the wall and projecting three inches, making the diameter there 12 feet 6 inches, cornice included. The Water Table to be capped with hewn stone of at least eight inches wide slopped to turn off the water. The floor to be paved with brick or stone. Stairs from the floor to the Lanthorn to be not less than 120 of either free stone or Pennsylvania marble, one end going at least six inches into the wall and the other end being a 9 inch newel forming a pillar in the centre of the house. A quarter landing to be at each revolution.—The whole work to be well bound and good lime mortar used throughout, and if brick, in Flemish or English bond; the bricks to be all sound and good, the two external and internal courses at least to be stock bricks and all to be inspected and approved be the Collector at Georgetown or his agent. The top of the building to be arched, reserving a place for a trap door, which is to be fitted to serve as an entrance to the Lanthorn, and to have a stone cornice covered with copper so as to preserve it from weather. On the top of the stone work are to be a sufficient number of substantial iron sleepers bedded therein and sloping from the centre, which are to be covered first with sheet iron, over which is to be laid a course of sheeting paper well soaked in, and paid wit tar, and then with sheet copper over the iron, the whole to be riveted together so as that the floor of the Lanthorn thus prepared shall be perfectly tight and strong, and as durable at least as upon ordinary mode of laying the copper on wood. The trap door is to be covered with sheet copper. The Light House is to be rough cast on the outside and painted inside, and to be furnished with a substantial panel door with iron hinges, lock and latch complete; and to have at each revolution of the stairs two windows, on opposite sides 2 feet by 9 inches. The door and windows to have stone sills, arches and jambs.

A complete iron Lanthorn in the octagon form, to rest thereon, with a compleat [sic] set of Lamps to be suspended by good and sufficient iron chains, so hung as that the Lamps may be raised or lowered at pleasure and also a sufficient number of air pipes. The eight corner posts or Stanchions of the Lanthorn to be built in the wall to the depth of eight feet; the ends within the wall to be secured by large Anchors; these posts are to be two and a half inches square in the lower end, and two inches square above the stone work.—The Lanthorn to be eight feet in the smallest diameter, and nine feet high from floor to the dome or

roof.—The roof to be four feet in height and covered with sheet Copper. The rafters of the Lanthorn (which are to be of iron) are to be framed into an iron hoop, over which is to be a copper funnel, through which the smoke may pass into a copper ventilator in the form of a ball capable of containing fifty gallons and large enough to secure the funnel against rain; this ventilator to be turned by a large vane, so that the hole for venting the smoke may be always to leeward. Eight dormant ventilators are to be fixed into the roof of the Lanthorn. The spaces between the posts and the angles, to be occupied by the sashes, which are to be of iron, moulded on the inside, struck solid and of sufficient strength so as not to work with the wind; each sash to be glazed with strong 10 by 12 glass of the first quality, and one of the sashes to be hung on hinges for a convenient door to go out on the platform, which is to be surrounded by iron Balustrades three feet high, each railing to be three quarters of an inch square, inserted in the braces between the eight posts. From the railing, a strong wire setting with two-inch mesh is to be carried all round the eaves of the Lanthorn, and also to extend round the gallery to the platform.

The building to be furnished with two complete electrical conductors or rods with points. Also a close stove is to be placed in the Lanthorn.

Persons disposed to contract will be pleased to transmit their proposals (which must also specify the shortest time within which they will undertake to complete the work) to the Collector of the Customs at Georgetown, South Carolina, on or before the first day of July next, who will immediately thereafter transmit them to the Treasury Department, from whence notice will be given of the accepted offer.

The proposals may be made for erecting the building either of brick or stone, and with either free stone or marble steps, and the persons offering them must specify in which of the two materials they are willing to undertake the work.

NOTES

Chapter 1

1. Snow, *Famous Lighthouses*, 195.
2. *Virginia Gazette*, "Charlestown," July 23, 1767: 2.
3. *Georgia Gazette*, "Charlestown," December 17, 1766: 2.
4. *New York Mercury*, "Charles-Town (in South Carolina)," December 29, 1766: 2.
5. *Georgia Gazette*, "Charlestown," October 7, 1767: 2.
6. Ibid., "Charlestown," August 24, 1768: 2.
7. Hennig Cohen, ed., "Four Letters from Peter Timothy," *South Carolina Historical Magazine* 55, no. 3 (July 1954): 160–65.
8. Vorsey Jr., *De Brahm's Report*, 91.
9. Jack Cross, ed., "Letters of Thomas Pinckney, 1775–1780," *South Carolina Historical Magazine* 58, no. 11 (January 1957): 19–33.
10. Peter Russell, "The Siege of Charles Town: Journal of Captain Peter Russell, December 25, 1779, to May 2, 1780," *American Historical Review* 4, no. 3 (April 1899): 478–501.
11. South Carolina Archives and History, General Assembly, Committee Reports, 1785, No. 7 516555, Box 27.
12. Ibid., 1787, No. 69 5165205, Box 28.
13. Ibid., 1787, No. 95 516505, Box 28.
14. Ibid., Resolutions, 1791, No. 13 S165018, Box 10.
15. Stewart, *The Lighthouse Act*, 17.

16. *New York Daily Gazette*, "Caution to Mariners," July 20, 1791: 3.

17. Daniel Stevens, "To the Merchants, Masters of Vessels, and the Pilots of Charleston," *South Carolina State Gazette*, August 2, 1799: 3.

18. Ibid., "Supervisor's Office," *South Carolina State Gazette*, September 10, 1799: 4.

19. National Archives, RG 26, Clipping Files, Charleston Main Lighthouse, SC.

20. *Georgia Gazette*, November 20, 1800: 3.

21. Furlong, *American Coast Pilot*, 92.

22. *City Gazette*, "Ship News," March 10, 1813: 3.

23. *New York Columbian*, "Notice to Mariners," April 5, 1813: 3.

24. Winslow Lewis, "Notice to Mariners," *National Advocate*, August 1, 1816: 2.

25. Mills, *American Pharos*, 72.

26. U.S. Light-House Establishment, *Compilation of Public Documents*, 739.

27. Snow, *Famous Lighthouses*, 194.

28. National Archives, RG 26, Clipping File, Charleston Main Lighthouse, SC.

29. L.R.G., "The Lighthouse and Lighthouse Island," *Charleston Courier*, November 9, 1842: 2.

30. Ludlum, *Early American Hurricanes*, 132–33.

31. National Archives, RG 26, Clipping File, Charleston Main Lighthouse, SC.

32. Ibid.

33. Ibid.

34. South Carolina Department of Archives and History, General Assembly Committee Reports, 1858, No. 132 S165015, Box 105.

35. Ibid., 1861, No. 89 S165005, Box 112.

36. *Charleston Courier*, "Charleston Lighthouse Destroyed," December 20, 1861: 2.

Chapter 2

37. National Archives, RG26, Clipping File, Georgetown Light Station, SC.

38. Furlong, *American Coast Pilot*, 204; see also National Archives, RG 26, Clipping File, Georgetown Light Station, SC.

39. *City Gazette*, "A Caution to Masters of Vessels," December 15, 1804: 3.

40. *Raleigh Register*, September 8, 1806.

41. Charles Brown, "Notice," *City Gazette*, October 14, 1806: 1.

42. National Archives, RG 26, Clipping File, Georgetown Light Station, SC.

43. Ludlum, *Early American Hurricanes*, 55–57.

44. Mills, *American Pharos*, 82.

45. Thomas L. Shaw, "Notice to Mariners," *Georgetown Union*, January 27, 1838: 3.

46. Blunt, *American Coast Pilot*, 42.

47. *Winyah Observer*, "The Ship *Atalanta*," September 25, 1850: 3.

48. National Archives, RG 26, Clipping File, Georgetown Light Station, SC.

49. Ibid.

50. Ibid.

51. W.H.C. Whiting, "Notice," *Pee Dee Times*, February 24, 1858: 3.

52. Rogers, *History of Georgetown County*, 401.

53. National Archives, RG 26, Clipping File, Georgetown Light Station, SC.

54. *Charleston Post and Courier*, "Georgetown Light," March 1, 1986: 12.

Chapter 3

55. Furlong, *American Coast Pilot*, 92.

56. *National Advocate*, September 12, 1816: 2.

57. *City Gazette*, "Melancholy Shipwreck," August 31, 1816: 2.

58. *New York Herald*, "Further of the Wreck of the *Diamond*," September 11, 1816: 2.

59. *American Mercury*, September 17, 1816: 3.

60. *Baltimore Patriot*, "Wreck of the Diamond," September 17, 1816: 2.

61. Christoval Soler, "Loss of the Spanish Schooner *Diamond*," *American Beacon*, September 16, 1816: 3.

62. Blunt, *American Coast Pilot*, 182–83.

63. South Carolina General Assembly Reports, "Resolution Appointing Commissioners to Mark the Windmill Lighthouse on Cape Romain to Distinguish it from the Charleston Lighthouse," S16501 1821 00026.

64. *Republican Beacon*, "Cape Romain," June 19, 1822: 1.

65. Blunt, *American Coast Pilot*, 252.

66. *Winyah Intelligencer*, March 21, 1827: 2.

67. Ibid., April 28, 1827: 2.

68. *Charleston Courier*, May 3, 1827: 2.

69. J.R. Pringle, "Information to Mariners," *Charleston Courier*, May 25, 1827: 1.

70. *Daily Phoenix*, "Coast Curiosity Gone," October 10, 1871: 2.
71. Mills, *American Pharos*, 72.
72. Blunt, *American Coast Pilot*, 42.
73. U.S. Light-House Establishment, *Compilation of Public Documents*, 739.
74. National Archives, RG 26, Clipping Files, Cape Romain, SC.
75. United States War Records Office, *Official Records* 12, 692–93.
76. Richardson, *Annual Report*, 623.
77. Dutton, *Charleston Earthquake*, 322–23.

Chapter 4

78. National Archives, RG 26, Site Files, Bulls Bay, SC.
79. National Archives, RG 26, Clipping Files, Bulls Bay, SC.
80. Blunt, *American Coast Pilot*, 56.
81. United States War Records Office, *Official Records* 12, 692.
82. United States War Records Office, *Official Records* 12, 695.
83. United States War Records Office, *Official Records* 15, 363–64.
84. National Archives, RG 26, Clipping Files, Bulls Bay, SC.
85. Ibid.
86. Ibid.
87. National Archives, RG 26, Site Files, Bulls Bay, SC.
88. National Archives, RG 26, Clipping Files, Bulls Bay, SC.
89. Ibid.
90. National Archives, RG 26, Site Files, Bulls Bay, SC.

Chapter 5

91. George W. Cullum, "Fort Sumter Lighthouse, Charleston Harbor," *Hunt's Merchant's Magazine* 34 (1856): 735.
92. National Archives, RG 26, Site Files, Fort Sumter, SC.
93. Ibid.
94. Ibid.
95. *Charleston News and Courier*, "The Siege of Fort Sumter," August 30, 1891: 1.
96. National Archives, RG 26, Correspondence 1901–1939, Charleston Harbor, SC, no. 1139.

97. Ibid.
98. Ibid.
99. Ibid.
100. Ibid.
101. Ibid.
102. Ibid.
103. Ibid.
104. Ibid.
105. Ibid.

Chapter 6

106. W.H.C. Whiting, "Notice to Mariners," March 8, 1859.
107. Annual Report of the Secretary of the Treasury on the State of the Finances for the Year 1876, "Report of the Light-House Board" (Washington, D.C.: Government Printing Office, 1876) 775.
108. *New York Herald*, "The Cyclone," August 31, 1881: 5.
109. United States Coast and Geodetic Survey, *Atlantic Local Coast Pilot*, 116.
110. George W. Cullum, "Notice to Mariners," *Hunt's Merchant's Magazine* (1856): 734.
111. Light House Board, 775.
112. Burton, *Siege of Charleston*, 64.
113. National Archives, RG 26, Site Files, Fort Ripley Shoal, SC.
114. Ibid.
115. National Archives, RG 26, Letters, Fort Ripley Shoal, SC.
116. National Archives, RG 26, Site Files, Fort Ripley Shoal, SC.
117. Ibid.
118. National Archives, RG 26, Correspondence 1901–1939, Fort Ripley Shoal, SC, no. 2667.

Chapter 7

119. *City Gazette*, "False Lights," July 10, 1824: 2.
120. *Charleston Courier*, "Resolution," February 28, 1838: 2.
121. National Archives, RG 26, Clipping File, Hunting Island Lighthouse, SC.
122. Ibid.
123. Ibid.

124. Ibid.

125. *Charleston Courier,* "Notice to Mariners," April 22, 1861: 4.

126. *New York Evening Post,* "Particulars of the Capture of Beaufort," November 15, 1861: 3.

127. *Daily True Delta,* "Light-House at Port Royal," November 28, 1861: 1.

128. P. Drayton, "Interesting Naval Reconnaissance at Port Royal," *New York Herald,* December 12, 1861: 2.

129. United States War Records Office, *Official Records* 12, 692.

130. Blunt, *American Coast Pilot,* 366.

131. National Archives, RG 26, Clipping File, Hunting Island Lighthouse, SC.

132. Ibid.

133. Ibid.

134. Ibid.

135. Ibid.

136. Ibid.

137. Ibid.

138. Ibid.

139. Ibid.

140. Ibid.

Chapter 8

141. National Archives, RG 26, Clipping File, Charleston Main Lighthouse, SC.

142. Ibid.

143. Refuse, *A Single Grand Victory,* 194.

144. National Archives, RG 26, Clipping File, Charleston Main Lighthouse, SC.

145. Ibid.

146. Ibid.

147. Ibid.

148. Ibid.

149. Ibid.

150. Ibid.

151. Ibid.

152. Ibid.

Chapter 9

153. F.B. Ellison, "Notice to Mariners," *Charleston Courier*, November 22, 1865: 2.
154. National Archives, RG 26, Site File, Hilton Head Lighthouse, SC.
155. W.A. Jones, "Proposals," *New York Herald*, August 22, 1878: 12.
156. National Archives, RG 26, Clipping File, Hilton Head Lighthouse, SC.
157. Ibid.
158. Ibid.
159. Ibid.
160. Ibid.
161. Ibid.
162. Ibid.
163. Ibid.
164. Ibid.
165. Ibid.
166. Ibid.
167. Ibid.
168. Ibid.

Chapter 10

169. Furlong, *American Coast Pilot*, 76.
170. National Archives, RG 26, Site Files, Haig Point, SC.
171. Ibid.
172. Ibid.
173. Ibid.
174. Ibid.
175. Marsher and Marsher, *Great Sea Island Storm*, 72–73.
176. National Archives, RG 26, Site Files, Daufuskie Island, SC.
177. Burn, *An Island Called Daufuskie*, 202–03.
178. National Archives, RG 26, Site Files, Daufuskie Island, SC.
179. Burn, *An Island Called Daufuskie*, 204.
180. Ibid.
181. United States Coast and Geodetic Survey, *Atlantic Local Coast Pilot*, 132.
182. National Archives, RG 26, Site Files, Daufuskie Island, SC.
183. Burn, *An Island Called Daufuskie*, 212.

184. National Archives, RG 26, Site Files, Daufuskie Island, SC.
185. *Charleston News and Courier*, "To Relight Buoy," November 14, 1912: 3.
186. National Archives, RG 26, Site Files, Daufuskie Island, SC.
187. Burn, *An Island Called Daufuskie*, 215–20.

Chapter 11

188. National Archives, RG 26, Correspondence, Charleston Harbor, SC.
189. National Archives, RG 26, Clipping Files, Charleston Lighthouse, SC.
190. Ibid.
191. *Augusta Chronicle*, "New Lighthouse Turned On," June 16, 1962: 1.
192. National Archives, RG 26, Clipping Files, Charleston Lighthouse, SC.

SELECTED BIBLIOGRAPHY

Blunt, Edmund M. *The American Coast Pilot*. 9th ed. New York: The Quadrant, 1822.

———. *The American Coast Pilot*. 19th ed. New York: Edmund Blunt and George W. Blunt, 1863.

Burn, Billie. *An Island Called Daufuskie*. Spartanburg, SC: The Reprint Company Publishers, 1999.

Burton, E. Milby. *The Siege of Charleston, 1861–1865*. Columbia: University of South Carolina Press, 1970.

Dutton, Charles Edward. *The Charleston Earthquake of August 31, 1886*. Washington, D.C.: Government Printing Office, 1890.

Furlong, Lawrence. *The American Coast Pilot*. 1st ed. Newburyport, MA: Blunt and March, 1796.

———. *The American Coast Pilot*. 3rd ed. Newburyport, MA: Edmund M. Blunt, 1800.

Holland, Francis Ross, Jr. *America's Lighthouses: An Illustrated History*. New York: Dover Publications, Inc., 1972.

Ludlum, David. *Early American Hurricanes*. Boston: American Meteorological Society, 1963.

Marsher, Bill, and Fran Marsher. *The Great Sea Island Storm*. San Jose, CA: Author's Choice Press, 2001.

Mills, Robert. *The American Pharos, or Light-House Guide*. Washington, D.C.: Thomason and Holmes, 1832.

Purdy, John. *The Columbian Navigator; or, Sailing Directory for the American Coasts and West Indies*. London: R.H. Laurie, 1823.

Refuse, Ethan Sepp. *A Single Grand Victory: The First Campaign and Battle of Manassas*. Wilmington, DE: Scholarly Resources Inc., 2002.

Richardson, William A. *Annual Report on the State of the Finance to the Forty-third Congress, First Session*. Washington, D.C.: Government Printing Office, 1873.

Rogers, George C. *The History of Georgetown County, South Carolina*. Columbia: University of South Carolina Press, 1970.

Snow, Edward Rowe. *Famous Lighthouses of America*. New York: Dodd, Mead & Company, 1955.

Stewart, Walter J. *The Lighthouse Act of 1789*. Washington, D.C.: U.S. Senate Historical Office, 1991.

United States Coast and Geodetic Survey. *Atlantic Local Coast Pilot: Sub-Division 20, Winyah Bay to Savannah with the Inland Passage to Fernandina*. Washington, D.C.: Government Printing Office, 1885.

United States War Records Office. *Official Records of the Union and Confederate Navies in the War of the Rebellion*. Washington, D.C.: Government Printing Office, 1894–1922.

U.S. Light-House Board. *List of Lights and Fog Signals on the Atlantic and Gulf Coasts of the United States*. Washington, D.C.: Government Printing Office, 1893.

U.S. Light-House Establishment. *Compilation of Public Documents and Extracts from Reports and Papers Relating to Light-Houses, Light-Vessels, and Illuminating Apparatus, and to Beacons, Buoys and Fog Signals, 1789–1871*. Washington, D.C.: Government Printing Office, 1871.

Vorsey, Louis D. *De Brahm's Report of the General Survey of the Southern District of North America*. Columbia: University of South Carolina Press, 1971.

Newspapers

American Beacon (Norfolk, VA)
American Mercury (Hartford, CT)
Augusta Chronicle
Baltimore Patriot
Charleston Courier
Charleston News and Courier
Charleston Post and Courier
City Gazette (Charleston, SC)
Daily Phoenix
Daily True Delta
Georgetown Union
Georgia Gazette
National Advocate
New York Columbian
New York Daily Gazette
New York Evening Post
New York Herald
New York Mercury
Pee Dee Times
Raleigh Register
Republican Beacon (Ithaca, NY)
South Carolina State Gazette
Virginia Gazette
Winyah Intelligencer

INDEX

ABOUT THE AUTHOR

John Hairr is an award-winning writer and historian who has written extensively about the history and lore of the southeastern United States and the Caribbean region. His writings have covered a wide range of topics, including wild rivers, shipwrecks and extinct wildlife. A member of the Outdoor Writers Association of America, his work has appeared in numerous publications, including *Mercator's World*, *South Carolina Wildlife* and *Fortean Times*. He is the author of several books, including two published by The History Press: *North Carolina Rivers: Facts, Legends and Lore* (2007) and *Great Hurricanes of North Carolina* (2008).

Visit us at
www.historypress.net
..

This title is also available as an e-book